Son of the Soil

Eldridge Bagley

Soul of an Artist

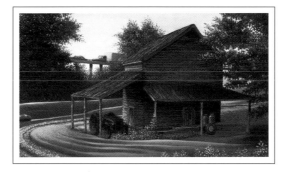

Paintings by Eldridge Bagley

Preface by Gerard C. Wertkin

Text by Susan Tyler Hitchcock

RAND MCNALLY

NICHOLSTONE

Copyright © 1997 by Cudahy's Gallery

All images copyright © Eldridge Bagley

Published by Rand McNally Book Services Group/Custom Products

Library of Congress Cataloging-in-Publication Data

Eldridge Bagley: Son of the Soil, Soul of an Artist

No index

1. Art 2. Biography

ISBN 1-57814-003-x

CIP 97-66732

Author: Susan Tyler Hitchcock

Managing Editor: Don J. Beville

Design: Designer's Ink.

Photographer: Robert Ziegler

Printed in the United States of America by
Rand McNally Book Services Group/Custom Products

Bound by Nicholstone Companies, Inc.

10 9 8 7 6 5 4 3 2 1

Distributed by: Cudahy's Gallery
1314 E. Cary Street
Richmond, VA 23219
804-782-1776

Acknowledgments • Many people have contributed in many ways to making my art and, ultimately, this book a reality. Neighbors and friends have provided much of the inspiration for my work, probably without being aware of it. Along the way I received enthusiastic support and invaluable wisdom when I needed it the most.

I am grateful to Cudahy's Gallery for introducing my work to a varied and expanding audience. I especially want to thank Helen Levinson and Peter Stearns. Their vision and tireless efforts were essential in bringing this book to fruition. I am also grateful to those who generously loaned paintings for inclusion in this book. Their help in doing so contributed greatly to the result we envisioned.

My art established its vital roots in family. My parents, sister, brother, nieces, nephew, my wife and son have all played a part in nurturing those roots. My parents started me on the road that would lead to my calling, and I am indebted to them. They helped me understand that, while destination is important, so is the journey.

Their love, their lives, and their example are so woven into my life that they have ultimately influenced the course of my artistic journey. I would hope that this sturdy heritage comes alive in the paintings I create and connects with the hearts of those who view them.

— ELDRIDGE BAGLEY

Preface • Eldridge Bagley is a born storyteller. I knew that the moment we met in 1992, at the opening reception of the annual exhibition of his paintings at Cudahy's, an art gallery in an attractively restored mercantile section of Richmond, Virginia, where he has shown his work since 1981. Affable and self-assured and speaking in the gentle cadences of his home in Lunenburg County, south central Virginia, he captivated his audience with one well-told story after another. They were not just any stories, either; he spoke of struggle in the face of change; the loss of traditional culture to the uncertainty of new ways; and of transcendence at the edge of darkness.

The exhibition itself was a revelation to me. Collectors, whose devotion to Bagley's work was obviously deep and abiding, vied with one another for places on the line that formed hours before the doors to the gallery were opened. Virtually every painting was sold in the first few minutes of the show, not an uncommon occurrence in these yearly presentations of Bagley's work. The artist himself seemed to remain serenely apart from the excitement that his paintings engendered, but genuinely appreciative of the interest being taken in them. One thing was certain: Bagley touched a chord, heartfelt and profound, that resonated in the lives of the men and women who gathered at Cudahy's that pleasant June day.

If Eldridge Bagley is a storyteller, his paintings are his preferred medium for conveying his messages. Although he is clearly interested in pure form and in the texture and color of things, as evidenced by his fine studies of the objects of everyday life, it is in narrative that he is able to give full expression to his creative voice. In these canvasses, the rhythms of seasonal change, the cycle of planting and harvesting, the pulse of life itself are vividly present. Here is the key, I believe, to the artist's remarkable ability to reach people and touch their hearts.

Bagley is a self-taught artist, but this fact alone tells us very little about his paintings. Contemporary self-taught artists, by definition, come to their work outside the institutional structures of the art world. Their work rarely evidences the influences of developments in the fine arts; neither does it acknowledge any debt to other self-taught artists, at least in the United States, where recognized "schools" of "naive" painting do not exist. Because of the essential autonomy of self-taught artists from received forms or artistic convention, there is little aesthetic unity among them. They remain resolutely individualistic.

Eldridge Bagley is one of this independent lot. He does, however, count Anna Mary Robertson ("Grandma") Moses (1860–1961)

as the direct inspiration for his decision to take up the making of art. Indeed, in the wake of her great public acceptance, Grandma Moses inspired many self-taught artists to express themselves with paint on canvas. Notwithstanding great differences in technique and approach to subject matter, Bagley shares an interest in rural life with the well-loved Hoosick Falls, New York, artist.

To be sure, in Bagley's work, a more gritty, hardscrabble kind of farm life is depicted. Less change had come to the rural environment at the time of Moses's major work. Moreover, in keeping with a tendency of older artists to reflect on the past, her paintings are replete with memories of a seemingly less complicated time. Although Moses did not always dwell on the pleasantness of country life, neither was she concerned with problems of poverty, pollution, and alienation. Bagley, who came to his art as a much younger person, is less at home among "memory" painters because he so often confronts the searing realities of the late twentieth century.

Where does one place Eldridge Bagley as an artist? The field of folk art has long been receptive to the work of self-taught artists, even when they do not reflect the kinds of inherited group or community expressions generally associated with the word "folk." But to suggest that Bagley is a folk artist provides no more insight into his work than to categorize him simply as self-taught. His work is multi-textured and highly original. If any context is especially appropriate, it may well be the tradition of the regionalist painters of the American mid-century, whose concerns for the struggles of ordinary people, the special light and color of the rural landscape, and recording of ways that are deeply embedded in the fabric of everyday life have illumined the heartland of America.

With a perceptive eye, an authentic voice, and the soul of a storyteller, Eldridge Bagley does exactly that. I am delighted that through the pages of this splendid book, the work of an American artist will be introduced to a new and wider audience.

GERARD C. WERTKIN
Director, Museum of American Folk Art
New York, New York

Table of Contents

Introduction • Eldridge Bagley paints what he knows. He captures the rural South in spirit and detail. He paints the joys and the hardships of the farm family life, a life that was quieter, calmer, rawer, rougher, than the suburban existence most Americans know today. Some of his paintings reach back into the 1940s, the decade when he was born, and others stare straight at the realities of today and tomorrow. He does not flinch from the unpleasant, and yet beneath it all, Eldridge Bagley conveys a love for all that he shows.

Bagley paints what he knows, and yet sadly, slowly, but surely, the world he knows is disappearing. Raised a third-generation tobacco farmer, he remembers the long summer days spent topping tobacco plants, coming home in the evening sweat-soaked, fingers black and sticky with tobacco wax. He remembers the harvest smell of smoke in the air, as barn fires blazed night and day to cure hundreds of sticks of tobacco. He remembers sunshine sifting through the warehouse skylights, illuminating the dust in the air, spotlighting great piles of golden leaves.

He lived the life of the tobacco farmer, but he also saw that life dwindle down. More and more tobacco was being raised by fewer and fewer people. Eldridge and his parents grew their last tobacco crop in 1974. The family had already diversified, having planted acres of strawberries and operating one of the area's first pick-your-own berry farms, which lasted into the 1990s.

In the early 1970s, Eldridge Bagley had also begun to diversify, discovering that he had a gift for line and color. His career transition was only an indirect response to the demise of the tobacco farm, in that he longed to record the ways of life disappearing around him. As his artistic career has matured, Bagley has turned to other subjects, but the heart of his work remains farm and family scenes from rural Virginia.

Eldridge Bagley: His Life

Born on December 18, 1945, the second of three children to Waverly and Patsy Bagley, Eldridge Bagley grew up assuming that he would be a farmer, too. His family was not poverty-stricken. They

made money enough to be flexible, to pay for music lessons for their children, to shift from one crop to another, and to send their children to college. "Everyone all around me was going to college," Bagley says. "But I never liked school, and I just couldn't see another four years of it."

His mind moved in the sweeps and spirals of creativity and invention, not in the straight lines of memorization expected by the teachers in those days. Even as a youngster, Bagley remembers, he liked to draw and doodle. He especially enjoyed designing imaginary cars: long, sleek bodies and big, brash fins.

At the age of 19, he joined the National Guard. Others around him were enlisting and getting sent off to Vietnam, a threat that hovered throughout his six years in the service. For basic training, he was sent to Fort Bragg, North Carolina, far from home for the first and only time in his life. When he completed his years of service, in 1971, he was a man without a clear sense of his future. "I had no idea what lay ahead," he says today. He got up in the morning, worked the tobacco fields, weeded the strawberries, and wondered what the rest of his life held in store.

In 1973, he read a *Readers Digest* article about Grandma Moses. "I was intrigued by the idea of what she could accomplish, starting at such a late age—someone with her rural background, someone without any training or exposure to the fine arts, someone who had nothing going for her except her talent and desire to create," says Bagley. "Her style was so uninhibited, so free and authentic. Something triggered the creative urge in me."

Curious to try, Eldridge Bagley went on a hunt for materials. At the dime store in neighboring Victoria, he found a paint-by-number kit. Instead of following the lines, though, he painted his own creation, a red covered bridge spanning a little stream against a background of fall foliage. He still owns that painting.

Family and neighbors took to his paintings immediately, asking him to paint pictures of their houses, their landscapes, even their pets. He sold his first painting in 1973. It pictured an abandoned country church. For that painting, a neighbor gladly paid six dollars.

As he became more adept, he started looking beyond paint-by-number. Masonite was cheap and accessible at hardware stores in those days. He could buy large sheets and cut them to suit the

images he wanted to paint. Certain aspects of his earliest painting style were driven by his chosen material, particularly the exacting detail with which he used a fine brush to paint leaves and wisps of straw, one by one, on the flat masonite surface.

In the early years, Bagley found ways to farm and paint. Only slowly did it dawn on him that he could make a living with his painting. Often people asked him to create paintings of their homes. Soon Bagley was making money as an artist, but he wanted more. He had stories to tell. He made a conscious decision to stop painting commissioned works, focusing instead on documenting the life he knew so well.

Eldridge Bagley dates his life as an artist back to 1973, when he was 27 years old. His first efforts to exhibit his work took place at arts and craft festivals around Lunenburg County. Successes at those, combined with the support and enthusiasm of his parents, relatives, and neighbors, meant that by 1975, at the age of 29, Bagley felt confident that he had found his calling. He painted and sold more than three hundred paintings between 1976 and 1979.

Bagley's first gallery exhibition took place in March 1979, when fourteen paintings hung in the upstairs gallery space in Richmond's Scott-McKennis Fine Art Gallery. The show received attention and praise, a first step in Bagley's awareness that his work could find its way, not just into the realm of country fairs, but also into urban galleries and art collections. Scott-McKennis invited him back for another show in December of that same year. Now given the main gallery space, Bagley displayed twenty-six full-sized paintings and thirty miniatures.

The honest ingenuousness of his art and his person struck responsive chords in country folk and city folk alike. "Up until I read that article about Grandma Moses, I had never really given a lot of thought about what I would do with my life," he was quoted in a newspaper at the time of his first one-man show. "I think I knew that something would come along, something that I wanted to do, but I wasn't thinking about anything until I started to paint."

In the spring of 1981, Bagley was one of a handful of artists showing work at a new artists' show organized by the recently opened Cudahy's Gallery, in Shockoe Slip, Richmond. That event began a long-term relationship between Bagley and Cudahy's, which continues to this day. Eldridge Bagley's annual one-man shows, held at Cudahy's every June from 1982 on, have become part of the rhythm of the Richmond art world.

While other artists might continue to search for more and more galleries, Bagley decided to remain loyal to Cudahy's. It has been a happy match, from both perspectives. Peter Cudahy Stearns, owner of Cudahy's Gallery, feels proud to be able to support and show the work of Eldridge Bagley. "His paintings reflect a way of life that is

fast fading," says Stearns. "They form a rich chronicle of changing life in rural Virginia."

It surprises Eldridge Bagley, though, when art critics call his work "folk art" or "primitive"; he never intended to create a style that fit into those categories. "I just paint," he says. "The dictionary says 'folk' means 'originating among or characteristic of the common people.'" With that definition, Bagley can agree.

Each spring and fall, Eldridge Bagley still visits a few of the local festivals where he got his start. There, his most popular items are his miniatures. These tiny framed squares, not more than three inches on a side, zoom in on homey details that symbolize the rural life: a sliced peach, a sugar bowl, laundry on the line, an ax stuck into a chopping block. These miniatures find their way into the homes of the country people he knows and loves.

While other men may have been building a family, Eldridge Bagley was building a career. In the late 1970s, he bought a house from his uncle, just a half mile down the road, and had it relocated next door to his parents' house. Built around 1915, it is a graceful little farmhouse with a porch and steep gables.

In 1990, Eldridge Bagley met Beth Campbell. The daughter of a United Methodist minister, she knew rural Virginia, but she didn't have one community that she could call home. When she and Bagley met, she was working as a nurse in the mother-infant unit of a hospital in Richmond. A year after meeting, they were married. While Beth might have liked to locate their new household closer to her work, she understood how important home was to Eldridge Bagley. She moved to Lunenburg County, making his home her own. Several years later, they built Eldridge a small studio building at the far edge of the field, a stone's throw from the house. The Bagleys—Eldridge, Beth, and their son Wade—still live on the family farm.

Eldridge Bagley: His Art

Eldridge Bagley paints by intuition. He has never been tutored in technique, color, or perspective, but he has always been sensitive to those elements of fine art. Now, in his mature years, he comments thoughtfully on what he sees in his own paintings. He speaks of challenging himself, of trying new perspectives and colors, understanding that art stays alive only when the artist pushes the limit.

As he began to take his art seriously, he began to study his predecessors, coming to respect the work of American greats like Thomas Hart Benton and Grant Wood. Still, he would now and

then get caught up short, as in 1983 when an art critic compared his leaves to those of the French Impressionist Henri Rousseau. "I looked him up and saw that his leaves do look like mine," Bagley told a reporter.

He describes his earlier paintings, like *The Apple House* (1982), as flat in texture and busy in content. Already in that painting, however, he was striving for the perspective of a Blue Ridge horizon, as the field lifts up over the yard and the mountain ridge lifts up beyond the field. Many of his landscapes are composed to maximize the play of hill upon hill, as in *Monday and Rain* (1985), where the bus peeks out around the bend, or in *Snowplow* (1990), where the snowplow has cut a swath of black asphalt through the snow-covered scene, curving through the landscape, up and over the hill.

In some paintings, Bagley takes this textured perspective and turns it into a technique for evoking the uneven surfaces of land and sky. He speaks of the "folds of land" in a painting like *Last of the Fireflies* (1991) and points out that as he began evoking the landscape in broad folds of green, he chose to do the same thing in the colors and lines that convey the sky.

Even in many of his still lifes, in which Bagley focuses in tightly on objects typical of a farmland home, he offers a long view to the out-of-doors. Filigree tree branches finger into the frame through the window in *In the Pantry* (1985). Blotchy, outdoor greenery seen through the open door balances out the wealth of color and texture in the floral bouquet of *Zinnias* (1994).

Bagley recognizes that his most frequent palette mirrors the colors of the rural Virginia landscape: the ruddy dirt shades of the Piedmont soil; the greens of grass, trees, and weeds; the weathered whitewash and rust-red roof paint of old houses. From a documentary painting like *Checking the Barn Fires* (1992), all the way to a political commentary like *Summer of '69* (1993), Bagley is exploring the colors that have surrounded him all his life.

Yet sometimes he strikes out in new directions. In *Rainless Summer* (1995), for example, Bagley says that he deliberately pushed himself toward a palette of dusty reds and yellows, away from the blue-greens ordinarily found in his leafy landscapes. In *Fruit Pan* (1995) he also explored new colors, plum purple, roseate orange, true turquoise. Trips to Florida have afforded Bagley a whole new range of colors, as shown in *Blue Moon Motel* (1993) and *On Grassy Key* (1996).

He begins with composition, pencil-sketching on the white canvas. He rarely paints from a photographic model, but occasionally uses photographs to render detail accurately, especially as he evokes automobiles and buildings. Some of the buildings in his paintings have specific references that he can name. The house being moved out of the city in *Exodus* (1989), for example, takes its steep gables and wraparound chimney from a house he knows in nearby Chase

City. As he painted the house in *This Land is My Land* (1992), he referred to an actual house in Lunenburg County. More often, though, houses, barns, and churches painted by Eldridge Bagley are composites, typifying the buildings that have surrounded him all his life.

The excitement comes when he moves from pencil sketch to the application of color, says Bagley. "Then the really creative part starts, as I begin to paint. I feel free to go by the lines I have sketched or to ignore them. As the painting progresses, I continue to add elements. I may think of things that I didn't even consider at the stage of the sketch. Once the first paint is on, I try to enhance the painting by blending or adding, more and more, until I am sure that my painting is finished."

As his work has been shown publicly, Eldridge Bagley has spent more time in the city, and his subject matter has shifted to include more images about the encroachment of urban life upon the country. His attitude toward this evolution is complex, not simply sentimental. Sometimes he treats the meeting of city and country as a conflict, as in *The Confrontation* (1987). Sometimes he treats it as coexistence, a stand-off, as in *Two Roads* (1990). And sometimes he slyly hints of a way out, as in *Exodus* (1989).

Yet the progression of content through Eldridge Bagley's career is not a straight line from country to city. His paintings zigzag through time, place, and meaning. He has not given up conveying the simple life of rural Virginia, as some of his most recent paintings show, like *Market Day* (1995) and *Game Checking Station* (1996). Sometimes he chooses a subject purely for its beauty, as in *Zinnias* (1994) or *Daily Grind* (1995). Other paintings tell a complex story, as in *Ann at the Old House Window* (1988), which comes from a moment in his sister's life. Other paintings convey a message, as in *Tin Man* (1989).

Message or not, Eldridge Bagley's paintings always defy the sentimental. He recognizes that much of his appeal comes from his deep familiarity with the landscapes of the past. He has lived a life connected to the seasons and the land. In his experience, people come together through family, church, and community. You know every person you meet and you share so much with them.

It is a world that is easy to idealize from afar. Close up, though, it is a real world, full of ups and downs, gains and losses, joys and hardships. "I work to create art of grit and substance," says Eldridge Bagley. His work is not all easy, but it takes us deeper, helping us see and remember times that may be passing but values that still hold strong.

Farm and Family

Last of the Fireflies

Oil on linen, 18 x 24 • 1991

EVERY FALL, the time comes around when you see the last of the lightning bugs. I have always wondered what day of the year it will happen.

I think of this as a cool, quiet evening, relaxed and stress-free. The tree has lost most of its leaves and the corn stalks are standing pretty dry. While the children chase fireflies, the father shucks a few buckets of corn to take up to the crib. It's a common type of corn crib that you see in the South, built up on pillars topped with tin, to keep out the rats and mice.

I pushed myself and stretched the perspective in this painting. The pickup truck is long, and the corn crib sits high up on the hill. The land and the sky are layered in folds of color.

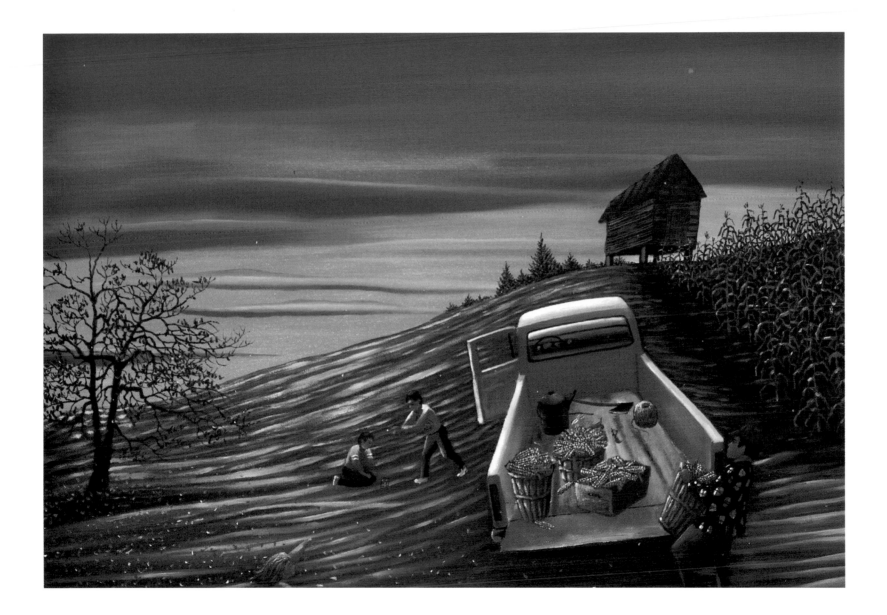

Shipping Cream
at the Kenbridge Depot

Oil on linen, 18 x 24 • 1992

THIS PAINTING comes straight from my life. It could be a photograph, but I painted it from my boyhood memory.

When I was growing up, we kept a dozen or so cows. We milked them by hand and sold the milk. My mother would use a big spoon and skim off the rich, thick, yellow cream, saving it up until she had a gallon or two. Then my father would take the can of cream to the Kenbridge Depot. He would tag it with our name and put it on the depot platform alongside other farmers' cream cans. I'm not sure who bought it, but we would get a little cream check now and then, to supplement our income.

That might be Daddy, leaning against the '51 Dodge pickup, talking. He's got feed bags in the back of the truck. What would so often happen is that the same morning, after leaving the cream at the depot, he would take bags of grain to the mill to be ground into feed.

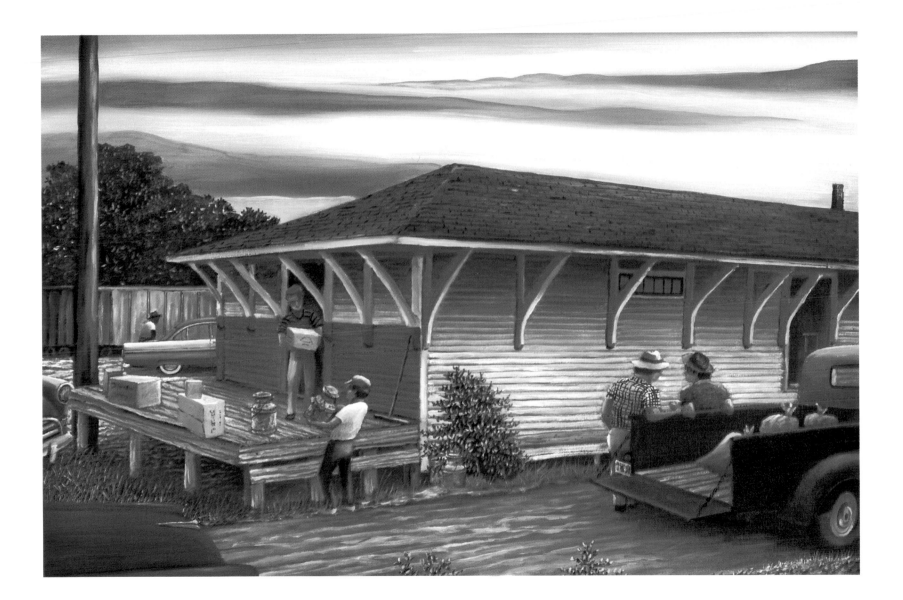

Checking the Barn Fires

Oil on linen, 18 x 24 • 1992

MY FATHER, both grandfathers, and a number of my uncles, cousins, and neighbors raised tobacco. I grew up a tobacco farmer, too. We cured it the old-fashioned way, in tall log barns. At one time, we had six tobacco barns like the three you see in this painting.

Each barn had a wood-burning furnace built inside. Smoke and heat circulated through flues inside of the building. When curing time came, between July and September, you had to keep up that fire, night and day, for almost a week. The heat in the barn would rise up to 180° or 200°, enough to knock you down when you opened the door.

Once they were cured, the leaves were so dry they would shatter if handled, so we threw in buckets of water onto the barn's dirt floor. Those dry leaves drew up that moisture and "came in order," as we used to call it when the leaves were properly cured. You had to watch the weather, though. Too much rain could make the tobacco too damp, so it would mold when you loaded it down.

Almost no one cures tobacco with wood anymore. In my mind, this painting shows the '60s, and even then, lots of tobacco farmers had gone over from wood to oil or gas. Nowadays, the leaves go into big bulk barns for curing.

Still, I love the lines and textures of the old tobacco barns, like those that populated the landscape in Lunenburg County as I was growing up. A few of them still stand, abandoned and overtaken by undergrowth. Each year, I notice more and more of them are gone.

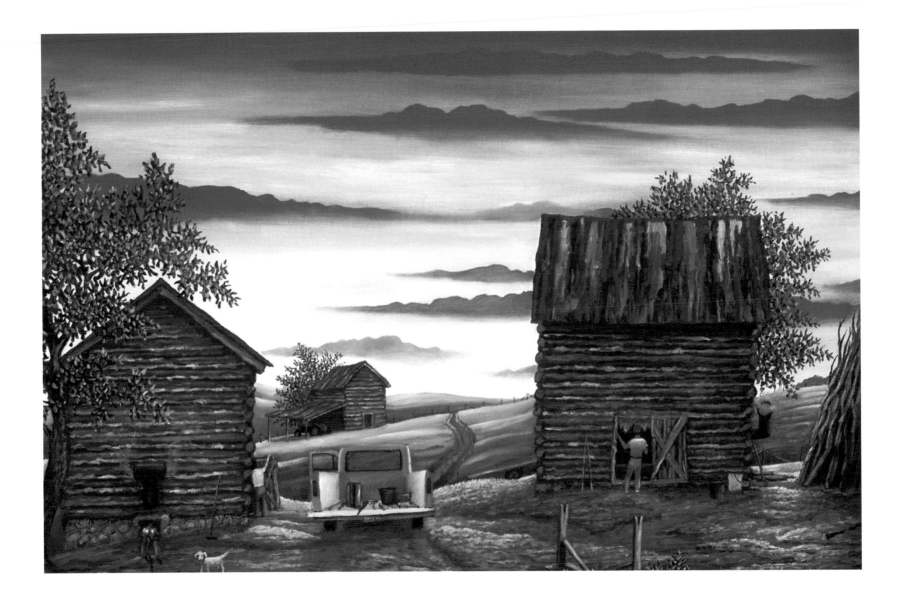

The Loss

Oil on canvas, 20 x 30 • 1989

MANY NIGHTS as I was growing up I would hear the siren howling through the night. Then, the next day, in Kenbridge, we would learn what happened. Or in the middle of the day, you would see a column of smoke billowing up, and you had the feeling that someone had lost a tobacco barn.

As I painted this scene, I imagined that the father, finding the fire, had gone back inside and called the fire department, fearing that it would do no good. The mother leans forward, comforting one child. The other child, just waking, is running toward the commotion. One by one, the members of the family have discovered the blaze. The fire trucks are driving up, but probably too late.

Near the burning barn, I painted details typical of a tobacco farm: the tall pile of firewood, the bucket tossed aside, the tobacco slide—a wood frame covered with old fertilizer bags, used to haul leaves from the field to the barn.

When a family lost a tobacco barn like this, they lost so much. There was all that time it had taken, planting the tobacco, getting it from the field to the curing stage. There was the barn, and anything else they might have had stored in or near it. Some people didn't have but one or two barns for curing, so losing one would set them back.

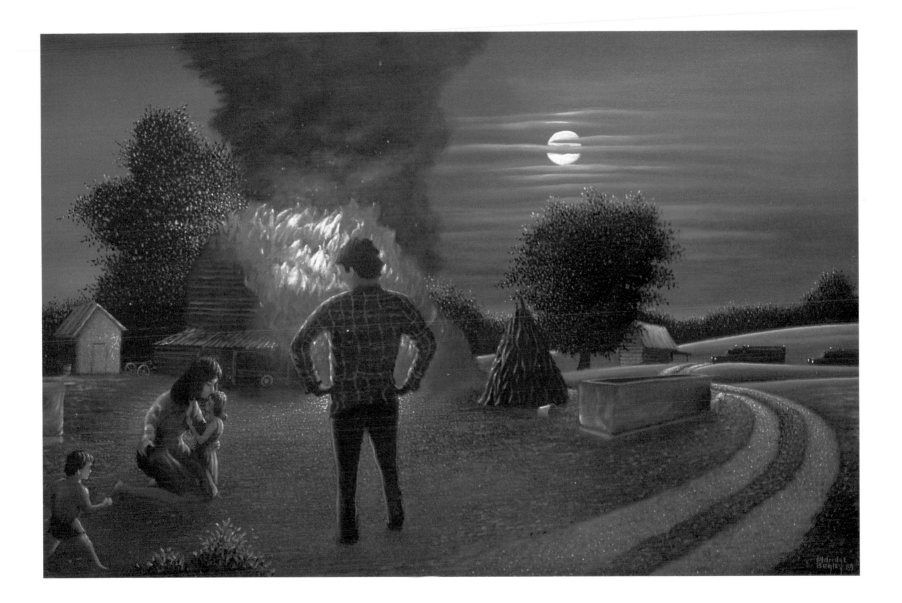

Market Day

Oil on linen, 18 x 24 • 1995

EVERYONE in a tobacco farming family looked forward all year to the day when the market opened. All of your work, all the things you had done to plant your crop, tend it, harvest, and get it ready to sell brought you to this time. You had done your best, working with or against nature. You booked some space in the market, brought your crop in and placed it on the floor. From there on, everything was beyond your control.

Auctioneers and buyers would move up the rows of graded tobacco, looking at the texture and the color of the leaf. You never knew from year to year what the buyers would want. Farmers took great pride in the way they presented their tobacco. There was an art to curing, sorting, and spreading out those golden heads of tobacco, hundreds of thousands of leaves.

Market day had a social side to it when I was a child. Wives and children would come along. I remember that rich, good smell of tobacco, permeating the entire warehouse. Shafts of light beamed down through the skylights, illuminating the dust particles in the air. We would drive in and unload each bundle onto a dolly, then wheel the tobacco over for weighing. Back then, Kenbridge was the third largest tobacco market in Virginia, with at least five warehouses. Now, only two operate there.

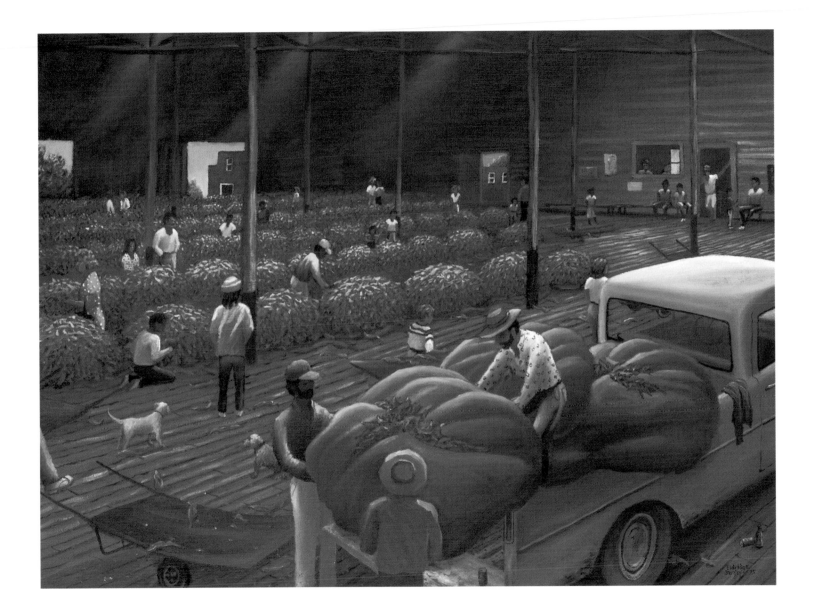

Monday and Rain

Oil on masonite, 16 x 20 • 1985

I LOOK UPON THIS as a growth painting. I was experimenting in a number of ways. I played with perspective, placing hills beyond hills. I played with color, creating a rather drab field upon which I splashed bits of color here and there: the umbrellas, the boots, the clothing, the bucket sitting outside the shed. I played with the textures of the plowed fields and experimented to discover how I could portray an image of falling rain.

It's a spring morning, with trees just beginning to bud. The children have to leave their farm home and board a bus to go to school. I have to admit that as a child, I didn't like school at all. I had better things to do. So what could be worse than going to school on a rainy Monday?

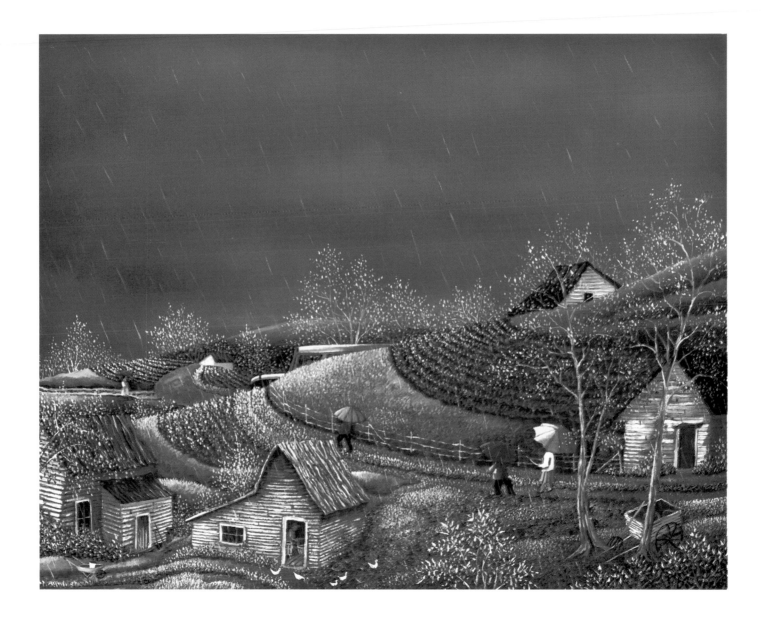

The Apple House
Oil on masonite, 16 x 20 • 1982

IN THIS PAINTING, I see signs of my earliest painting techniques. The buildings are shown with little perspective. The figures appear less agile than those in my later work, and I have chosen to portray a number of small figures and a variety of activities going on together. In those days, I enjoyed rendering leaves in minute detail, a brush stroke for every leaf on the tree.

The Bagley family never grew this many apples, although I distinctly remember helping an elderly neighbor lady harvest her apples and pressing them into cider under the shade of the apple trees. Many a farm family would spend an entire day, gathering, sorting, and packing apples. The building on the right may once have been someone's little house, but now the family uses it to store apples into the winter.

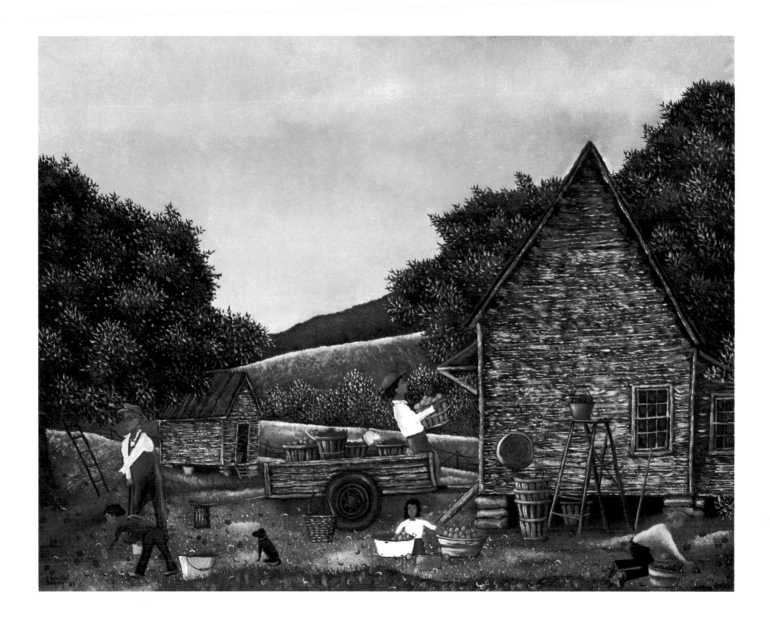

Game Checking Station

Oil on linen, 18 x 24 • 1996

THROUGHOUT THE SOUTH, you can see this scene on a brisk, cold day in November. A few hunters gather at their favorite country store. They check in their game, sip a cup of coffee, lean up against their mud-splashed four-wheel-drives, and talk.

Every country store has its own personality. I modeled this one after a store I know, but I renamed it. You can see by the style of the pickup trucks, by the coolers and the Pepsi machine, that this scene is contemporary.

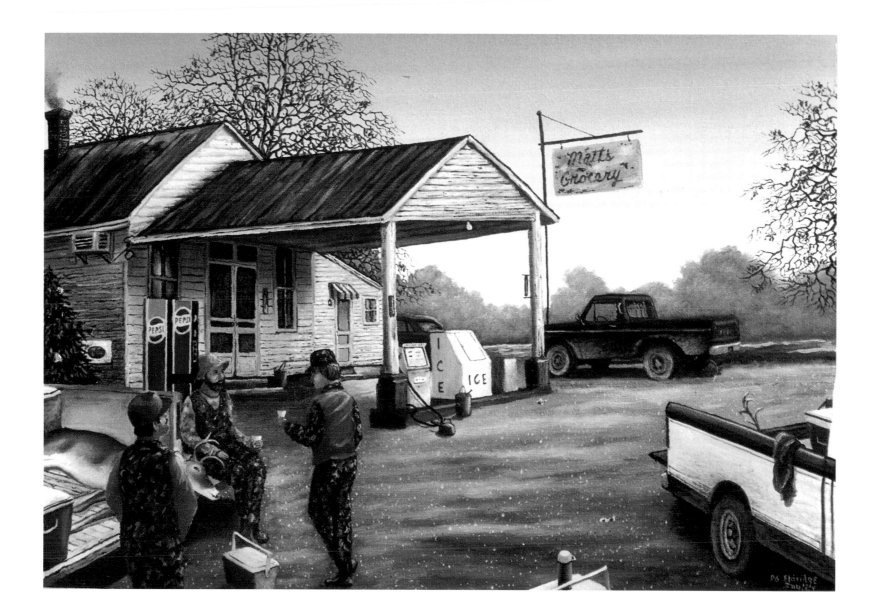

Struggles

This Land is My Land

Oil on linen, 18 x 24 • 1992

I DIDN'T HAVE the well-known song in mind when I painted this family scene. That phrase just seemed to express the contentedness I feel in these people's lives.

I do consider this family contented, although they may not seem that way in the eyes of the world. They may not have much, and it may not be fancy. But they do have a house, and they do own some land, even if it's just a fraction of an acre. For them, it's enough.

This scene is straight out of real life. I wanted to make it as realistic as it could be, so I added details—the antifreeze jug, the rusty '70s Dodge, the torn tarpaper, bare earth in the yard. I wanted to portray a family living comfortably in circumstances that others might not find so comfortable.

What's so ironic about this painting is that I couldn't stand living like this. I want a well-mown lawn. I want fresh paint and pretty things all around. A lot of other people feel the way I do, but I wanted them to take a closer look at a family like this one, rather than passing by without a glance or, worse yet, with a look of scorn.

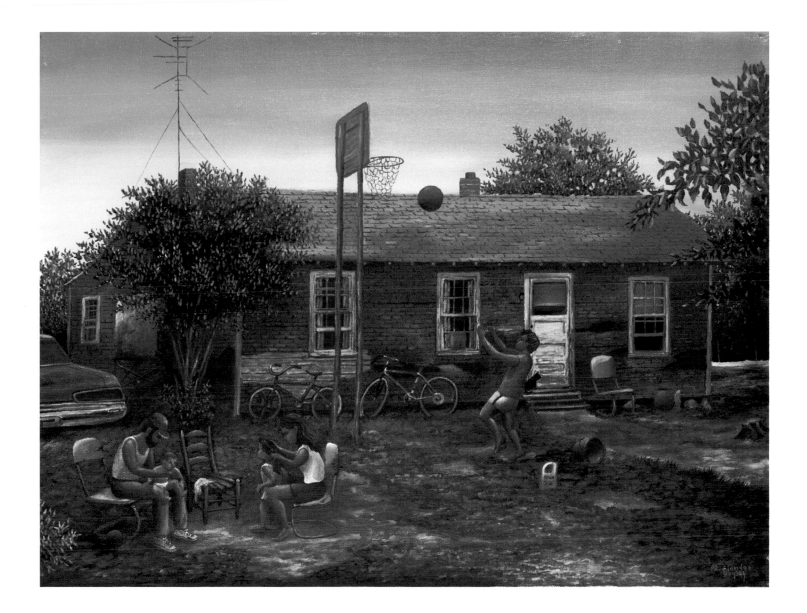

Habitat

Oil on linen, 18 x 24 • 1992

ALL THE WAY BACK through childhood, I remember seeing individuals, even families, who made their home in ramshackle huts or schoolbuses. They live a quiet, unnoticed life, so understated compared to the life screamed out at us today by television, radio, and newspapers. I deliberately chose drab colors in painting this scene, inviting people to look more closely and to make a connection.

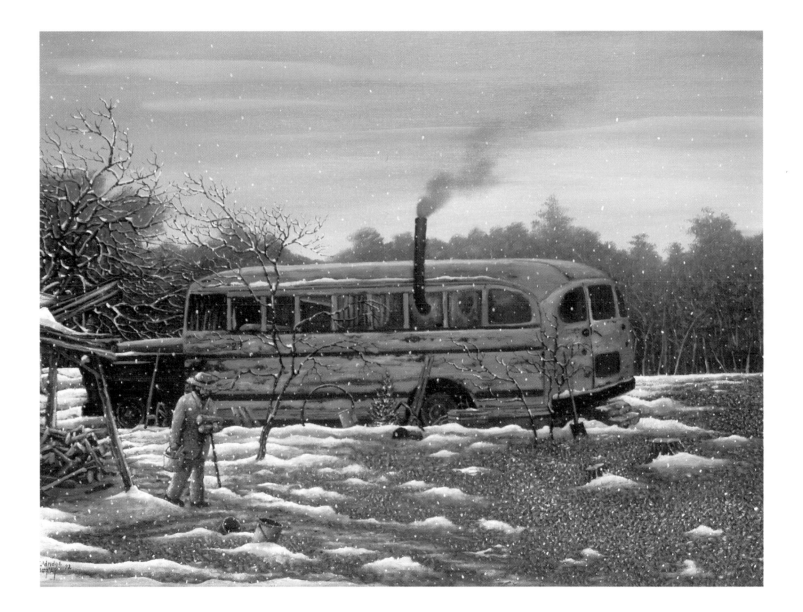

Rainless Summer

Oil on linen, 18 x 24 • 1995

I REMEMBER the driest year that our family farmed through, in 1963, when I was seventeen years old. The year before, Daddy had just bought more farm land, so we especially needed a good crop. That year a hail-storm ruined the tobacco. The next year, we struggled through a drought-ridden summer. Two bad years in a row, and we needed the income so badly.

Drought beats down a farming family in so many ways. Not only do you lose your crops, but your pastures dry up, so you don't have enough to feed your livestock. Forced to sell the cattle, you get little in return, since they have lost so much weight. All the other farmers are facing the same situation, so the market is glutted and your cattle can't possibly bring a good price.

I tried to show these layers of struggle through a number of elements—the parched land, the empty irriga-tion pond, the dust clouds behind the truck, the rib cages of the cows. This painting represents one of my strongest attempts to tell a story by the choice of color, using drab earth tones and very little green.

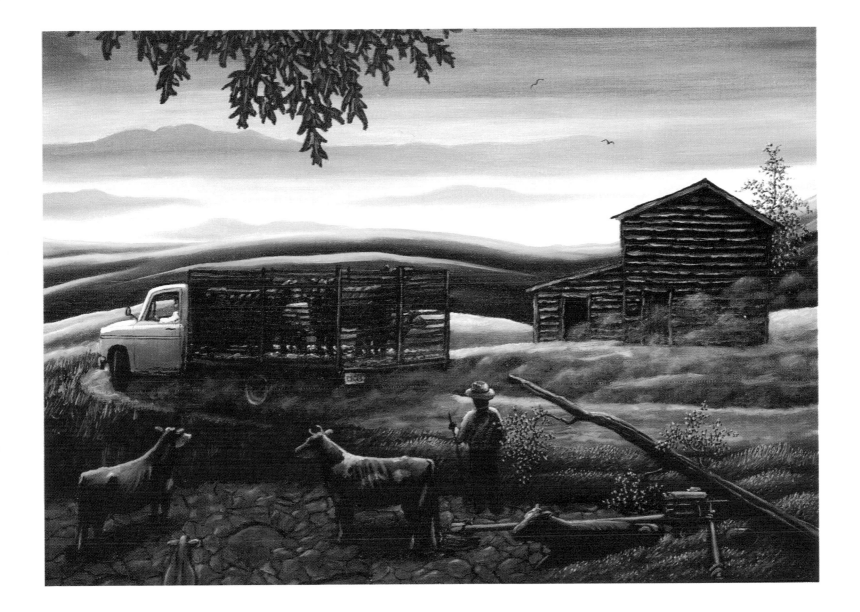

Mother's Day

Oil on canvas, 24 x 30 • 1996

I CONSIDER THIS PAINTING to be a tribute to my mother, who died in 1993. In the painting, I am sitting on our family grave plot in the Kenbridge cemetery with my brother, Grayson, and my sister, Ann. We actually did this. We talked a lot after my mother died. We did what every family needs to do at that time of loss. We cried together, but we also laughed together, and we shared so much. I wanted to convey a sense of how, amidst suffering and loss, one can find healing.

I used color sparingly in this painting. The only true colors are found in the flowers, which were a source of comfort, and in the water spigot, which stands near my mother's grave.

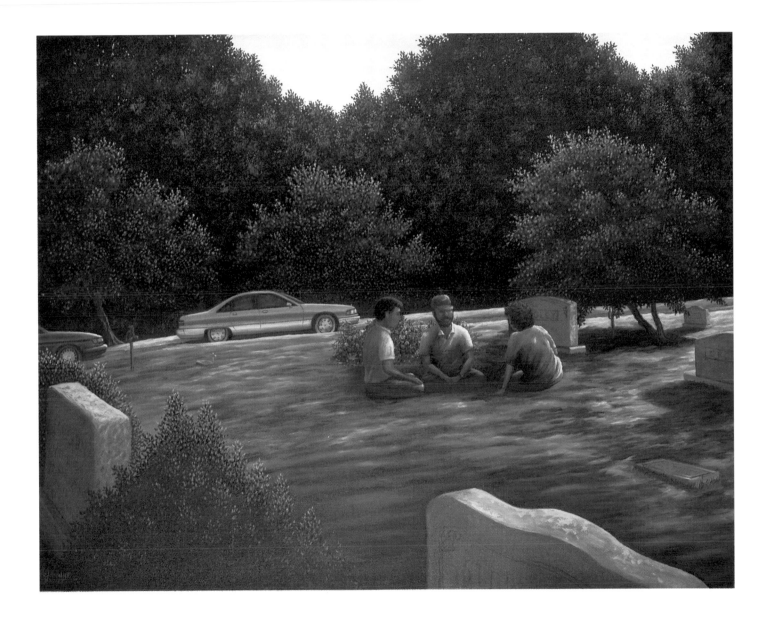

Fly Away

Oil on linen, 24 x 18 • 1993

Some bright morning, when this life is o'er,

I'll fly away.

To that home on God's celestial shore

I'll fly away, fly away.

Traditional Spiritual

MY MOTHER DIED in June, a week before the scheduled opening of my annual show at Cudahy's Gallery in Richmond. I had intended to do one more painting during that week. This was the result.

I have never worked at such a pace. I poured my heart into it. I thought of myself as the boy, sitting on the grass. The bird in the air symbolizes the spirit. The church, quietly settling with age, is like so many that I have attended for Sunday services and revivals.

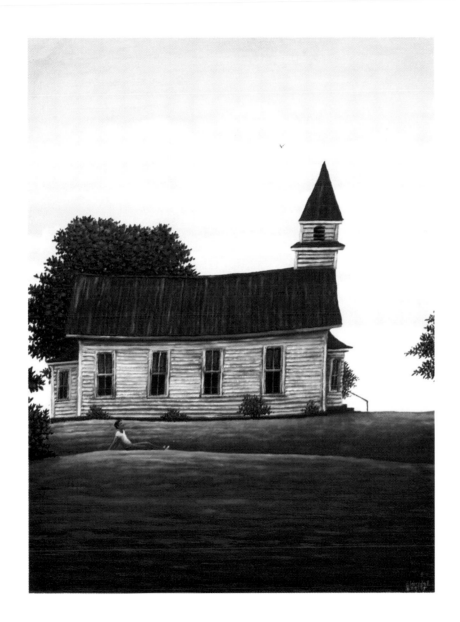

Winter

Snowplow

Oil on linen, 18 x 24 • 1990

IT'S A WELCOME SOUND, after a deep snowfall—that sound of the snowplow blade scraping on asphalt, slowly moving closer from a mile or two away.

In composing this painting, I was pushing toward abstraction: the sharp contrast between dark pine forest and new white snow, the ribbon of road that cuts through and divides the canvas, the play of perspective going up the hill and over.

The little house in the corner shows smoke coming out of the chimneys and an inside light, glowing through the window. Both details occur repeatedly in my work, symbolizing warmth, welcome, family, and home.

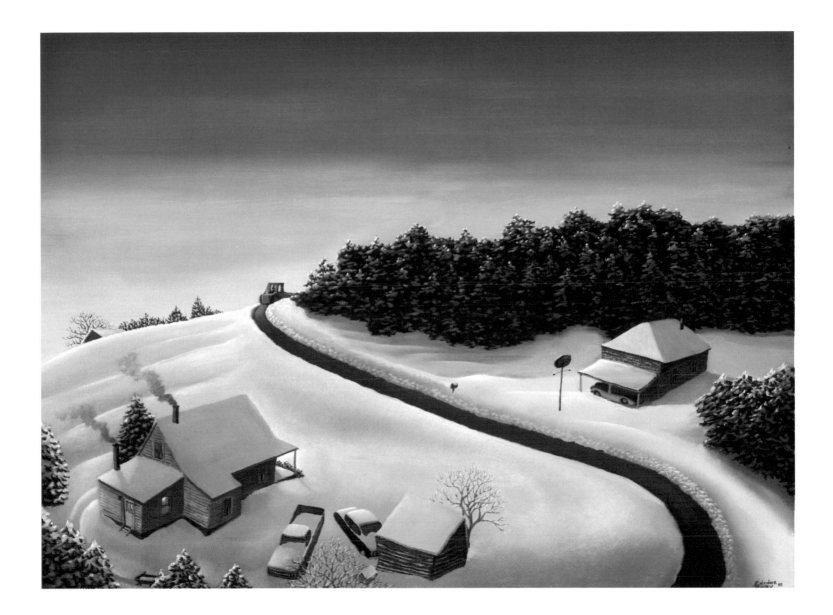

5:07 Departure

Oil on canvas, 24 x 36 • 1986

THE AUTOMOBILES in this painting show its era: the late 1950s, when trains still chugged through Southside Virginia, carrying people to visit family and friends far away. Only once have I ridden the train, and that was just on a fourth-grade field trip. Still, the lure of the train, especially trains of years gone by, continues to work on my imagination.

I think of these people, walking through the crusty snow and waiting comfortably inside the station. Then, entering the warm train, they begin a long journey, perhaps to visit distant relatives. The lady in the center has dropped her suitcase, and a man is helping to gather her belongings. He may be a relative, he may be a stranger. It is cold enough for snow to cling to their coats.

For this piece, I chose a larger canvas than I ordinarily use. It gave me the opportunity to stretch out, with more space to tell the story.

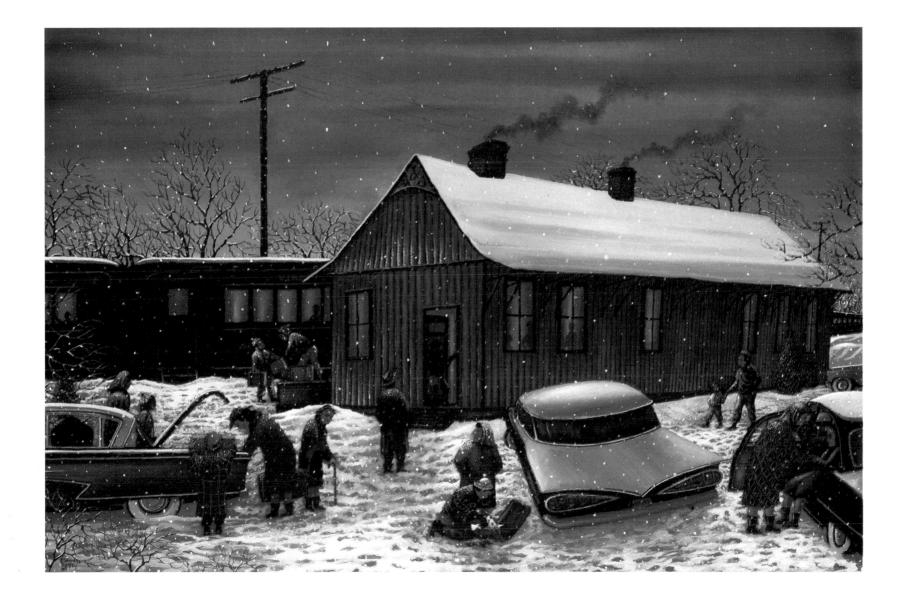

Home for Christmas

Oil on masonite, 16 x 36 • 1976

The lonely traveler still believes
The only gift a traveler needs
Is to find the road that leads him
Home again for Christmas.

© 1986 Eldridge Bagley

AN EARLY MILESTONE PAINTING, this piece does not depict a particular event. However, I trace the feelings in this painting back to a memorable Christmas in my life.

In 1966, I was stationed at Fort Bragg, North Carolina, just having finished basic training in the National Guard. My commanding officer doubted I would be released for the holidays, and I was feeling homesick. At the last minute, I got permission to go home. I rode the bus out of a cold and rainy Fort Bragg, into a snowstorm as we approached South Hill, Virginia. There, through the snow, I saw the familiar shape of my parents' car, parked in front of the tiny bus station. The Christmas lights glowed through the falling snow as we drove through Kenbridge. That Christmas, I gained a new appreciation of home and realized that I had always taken it for granted.

That was seven years before I even started painting. I remembered those feelings but created a different scene, with the '52 Studebaker taxi and the young man stepping out at his front door, greeted by smoke rising from the chimney and a light on inside.

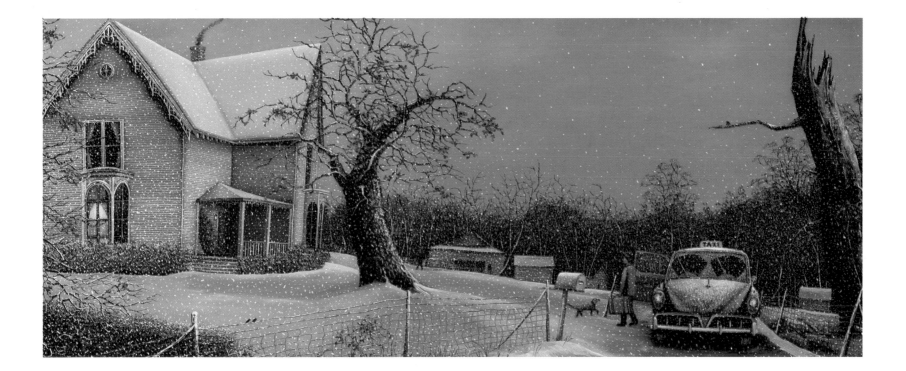

Approaching Christmas

Oil on linen, 18 x 24 • 1990

Waiting through the dark December nights
Far beyond the tumult and the lights—
A silent space where earth may not encroach;
A quiet place where Christmas may approach.

© 1994 Eldridge Bagley

I KNEW EXACTLY WHAT I WANTED to do as I set out to create this painting. I wanted to portray a simple homestead with little adornment or anything appealing, really, except Christmas decorations. It's a tiny house, worn and needing paint. The television antenna tells you that it's modern-day, but the stack of wood on the porch tells you this household heats with wood stoves. Yellow light glows from within. A crescent moon floats above.

The title means two different things. It can mean that Christmas is coming, so we string lights and decorate the tree. It can also question how we approach Christmas. A little spotlight brings attention to the handmade feed trough on the porch. At a glance, this is the home of the poverty-stricken—but didn't Christmas begin in just such a humble estate?

Even those in the humblest of circumstances can observe Christmas in the fullest and most meaningful way. Through years of experience, through years of making do or doing without, I know this to be true: strip away all the trappings, all the glitter and tinsel and gold, and you can still know Christmas in your heart.

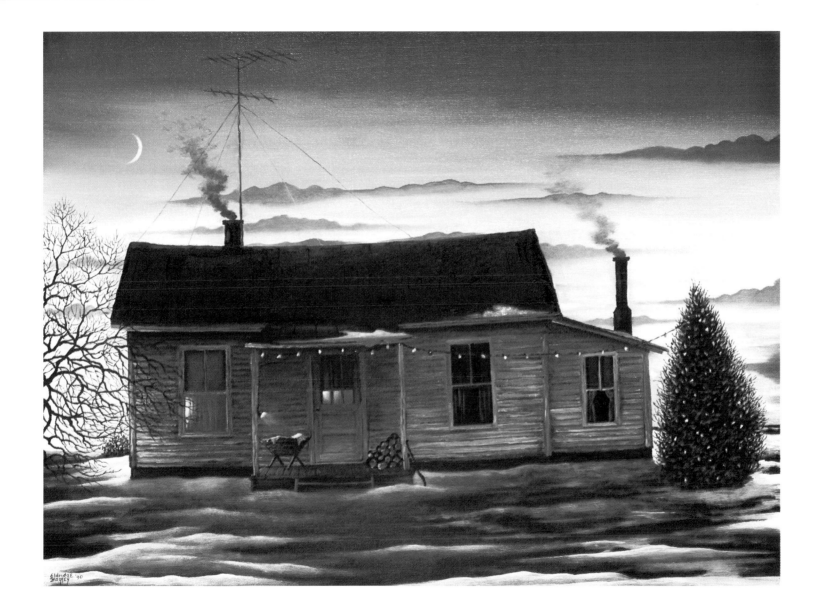

Night Train

Oil on linen, 18 x 24 • 1990

THIS IS a cold, quiet landscape. I was aiming for a sense of isolation from the turmoil of life. I hear the train whistle—mournful, but not sad—a sign that people are moving on their way to some distant destination. The chair, in my mind, has been sitting there since September, when someone pulled it out to sit and watch the sunset.

I worked with light and dark in this painting, creating the folds and dimples in the snow and the shadow cast by the tree on the snow drifts. It's the 1950s, judging from the locomotive and the hood of the car, jutting in from the edge of the painting.

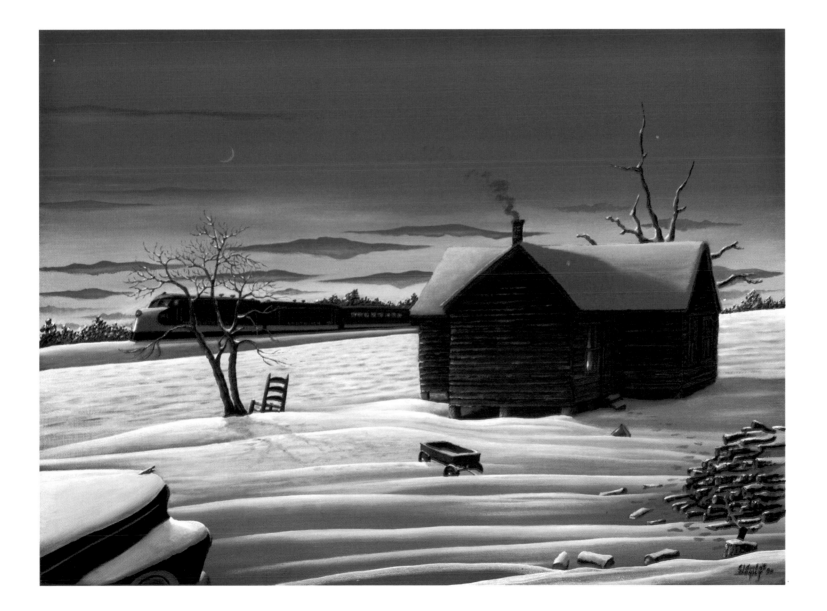

Southern Snow

Oil on linen, 18 x 24 • 1996

The silent, swirling southern snow
crept in at evening—and below
the Christmas air that wrapped our town
gently lay the snowflakes down.

Shoppers, dodging through the drifts,
spoke in whispers—hid their gifts.
The streets grew white without a sound
on Christmas Eve in our hometown.

THIS ISN'T Kenbridge, Victoria, South Hill, or Crewe—towns nearby my Lunenburg County home—but it's a composite of all of them, and other small towns of the South as well. Two-story brick buildings front up to the main street. Street lamps glow through the snowfall. Smokestacks and a water tower loom at the edge of town.

Yet to me, this isn't just a town. More than that, it's a hometown. It's a place that draws you home, a place that invites you to return, again and again. I chose to paint it from an aerial perspective, so that the viewer can take in the full sweep of this hometown and the many layers of life within it.

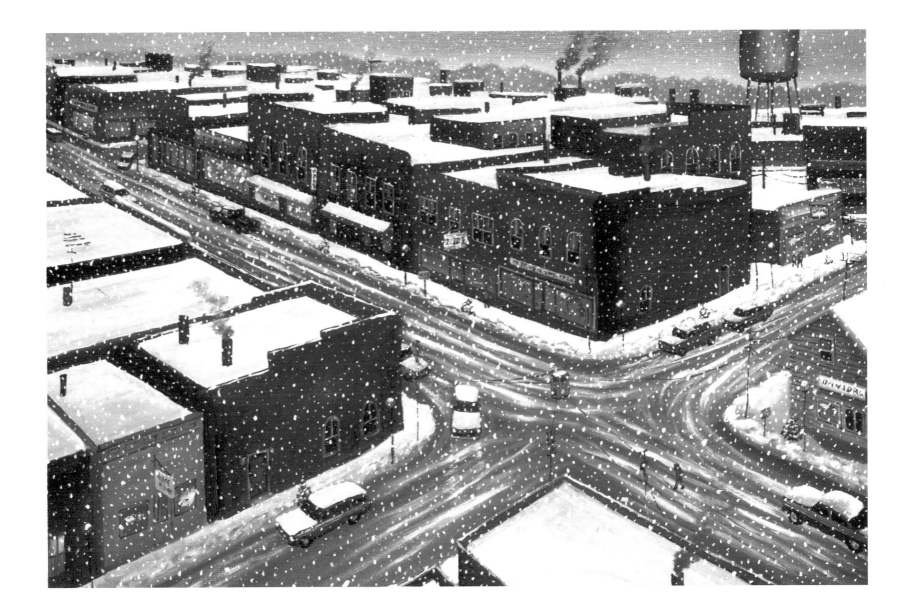

Flight #703

Oil on canvas, 20 x 24 • 1988

MY VISION HERE was to create two separate worlds, coexisting. They are entirely different, one from the other, in sight of each other, only barely interacting.

The house has been there longer than many of the buildings in the city below. It represents continuity. The city, growing in the distance, represents change, not necessarily all bad. I don't imagine that the city will ever move up here on the hill. In the distance, beyond the city, blue mountains lift up to the skies. Nature surrounds civilization, assuring us that the city will not grow infinitely.

The people who live in the house have come outside at the sound of the jet climbing overhead. In my mind, they know someone on the jet, and knew just when to listen for its ascent—but of course, viewers of this painting might interpret it differently.

As I painted this scene, I was deliberately expanding my abilities, seeking to represent the folds and shadows of land and sky, the textures of a terrain, and the perspective of a distant vista.

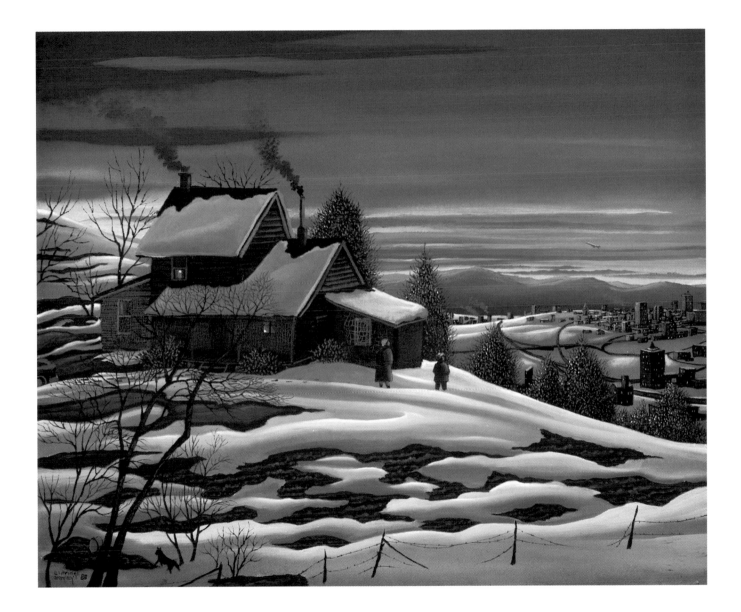

When Country and City Meet

The Confrontation

Oil on canvas, 20 x 30 • 1987

IN THIS PAINTING, human progress has become threatening. Urban development is indeed encroaching on home in the country.

This family probably owns the old house where they live. They have already watched a superhighway move in on their landscape. You can see the cloverleaf, the overpass, the trucks in the distance. Now that world is coming even closer, plowing up their front yard. The bulldozer is pushing down an old weathered outbuilding. I have seen all this before.

My sense is that this family can only acknowledge what is happening. They don't like it, but they have no choice. The father is talking to the head man on the construction job. The mother stands, almost defiantly, with her hand on her hip. Behind her, there is a pan and a bushel basket full of snap beans, signifying the rural life they want to keep living.

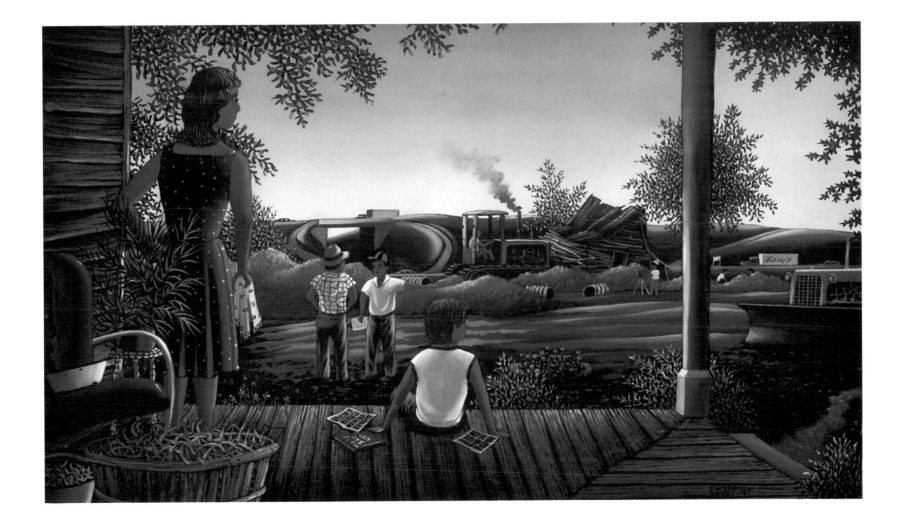

Two Roads

Oil on linen, 18 x 24 • 1990

THE URBAN AND THE RURAL stand back to back in this painting. Within each domain, it's business as usual. In the foreground, an old tobacco barn stands, still intact. A tractor has been parked under the shed roof, and it looks as if farm work is still going on. There are cows grazing nearby, milk cans line up alongside the shed, and a well-worn farm road encircles the barnyard.

Looming above the horizon, cars and trucks speed by on an elevated superhighway, far enough above and beyond the tobacco barn that those driving by take no notice of the rural scene. One might question what the future holds for this farm.

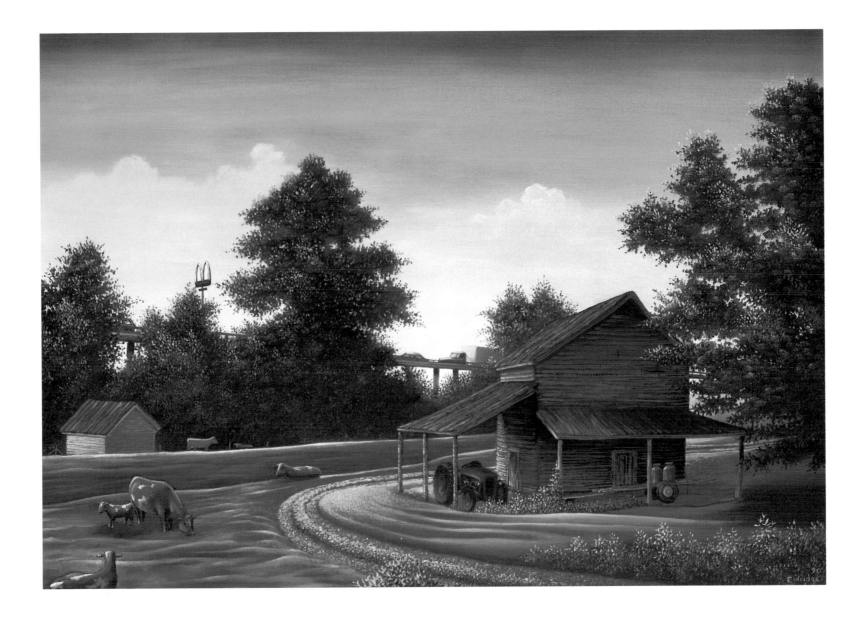

Back Yard Cruise

Oil on linen, 18 x 24 • 1990

Friends keep sendin' me postcards

The world keeps gettin' smaller

While I just sit in my back yard

And watch the grass grow taller

They say that I should see the world

Cruise down to Jamaica—

But for now I'm satisfied

Here on my quarter acre

THE PEOPLE in this painting don't need to go anywhere for entertainment. They are happy to take a cruise without leaving their own back yard. The children have their bathing suits on. The father is sitting in his outdoor lounge chair. The mother is enjoying herself, watering her flowers. The city rises up at the edge of their landscape, but it offers a tableau for them to watch. I don't see a threat here . . . or at least the people in the painting don't see one.

A traffic helicopter is flying nearby, suggesting that the traffic is moving in on them. But they don't seem to see it as a problem. They enjoy staying home.

This painting includes a lot of details that have become recurrent signatures of my work: delicate brush strokes, to indicate foliage; and scattered items, to represent the reality of family life, like the lawnmower, the beach ball, and the bucket hanging on the outdoor spigot.

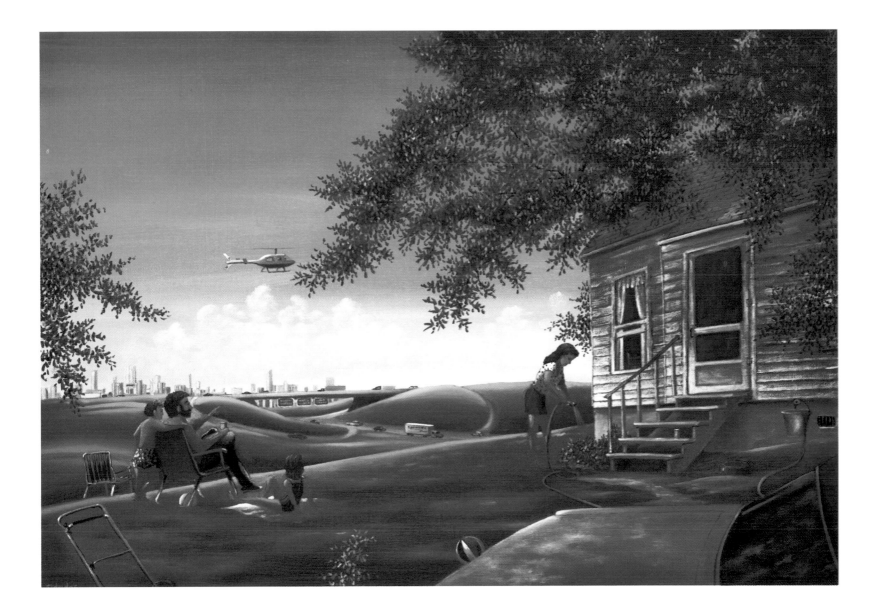

Exodus

Oil on canvas, 18 x 24 • 1989

IN 1977, I bought a house from my uncle and had it moved to my parents' farm. I have added on to it, making it my own. I am sure that the vision of that house, being hauled down the road by truck, fed my imagination as I worked on this painting.

But here, something different is happening. People have found a way to escape the city that threatens to take over. I imagine that this house might have stood in an area planned for demolition and rebuilding, so its owners had it put on a truck bed and hauled away. I think many city dwellers would like to do something like this—find a way to escape the city growing up all around them. These people have found a way to leave the traffic and pollution behind, and they are taking home with them.

The lines of the house being hauled to the country here come directly from a house that stands in Chase City, Virginia, twenty miles from my own home. That house remains on the site where it was originally built.

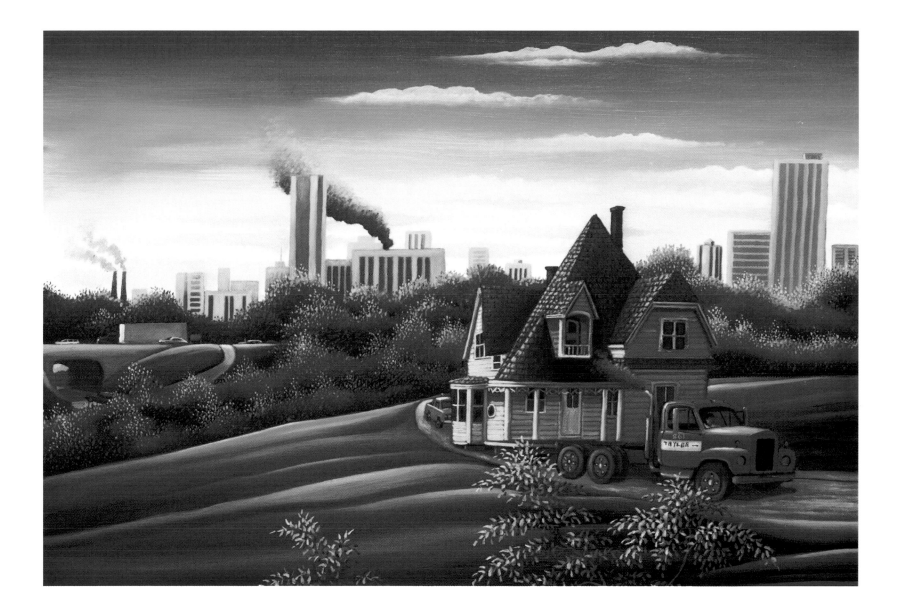

Still Life

In the Stable

Oil on masonite, 16 x 20 • 1981

THIS IS AN EARLY STILL LIFE, from the time when I was painting on masonite rather than canvas. It was part of a new artists' show at Cudahy's Gallery in Richmond in 1981.

A great amount of time was required to achieve the effect that I wanted in this painting. Every straw of hay is a separate brush stroke. The masonite medium allowed that fineness of detail. In fact, I would not have been able to paint like this on canvas in those days, because of the texture of the canvas, but I have since learned how.

I wanted to focus in on a scene within the stable, which is such an important building on any farm. The animals live in the stable and their food is stored there. Bantam chickens peck their way through the hay and find places to lay their eggs. I pictured a few eggs, some still hidden and some discovered; a milking stool; a milk can; and a blue enamel bucket. I added a few rust spots, to make the bucket look real, and used. I wanted to evoke the grain and color of an old worn pine floor.

I look upon this as one of my breakthrough paintings. It was the first large interior that I painted, focusing on detail rather than an expansive view. I tried new dimensions of perspective and depth, and I worked with light and shadow as I had never done before.

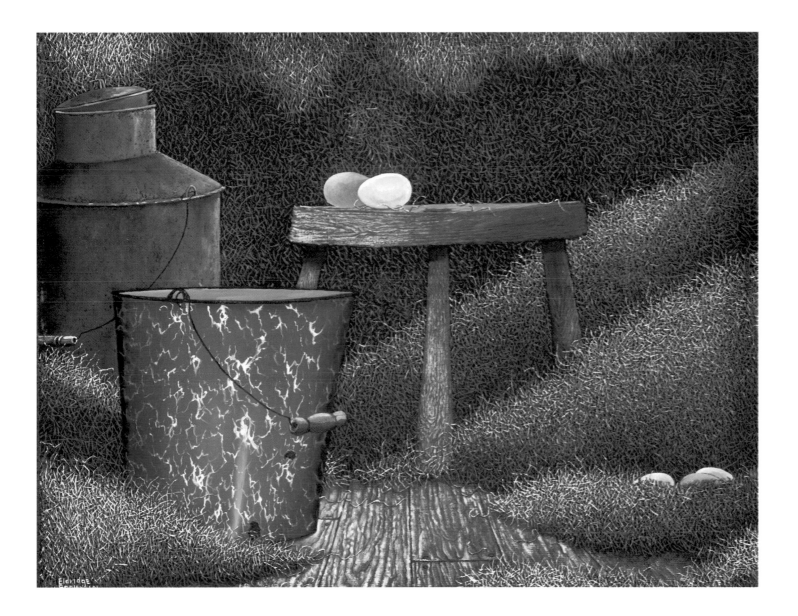

In the Pantry

Oil on masonite, 20 x 16 • 1985

IN THE EARLY YEARS of my career, I did very few still lifes. They still represent only a small segment of my work, especially among the larger paintings.

In this one, I imagined a scene in the corner of a pantry, a little work space where someone had placed newly churned butter and fresh eggs.

Homemade butter was a special treat when it came to our house. My grandmother made it. In fact, that's her butter mold in the painting. Neighbors also made it and gave it to us as a gift now and then.

I used a lot of circles and ovals in this painting: the loops of the handles on the basket and the pitcher, the eggs, the butter mold, the plate, the butter. This is one of the first paintings in which I experimented with folded, patterned cloth. Since then, those sorts of patterns occur frequently in my still lifes.

Another element here that recurs in later works is the window, through which you can see just a few branches of a tree. I enjoy putting a window to the out-of-doors in my still lifes. It gives the viewer a glimpse beyond.

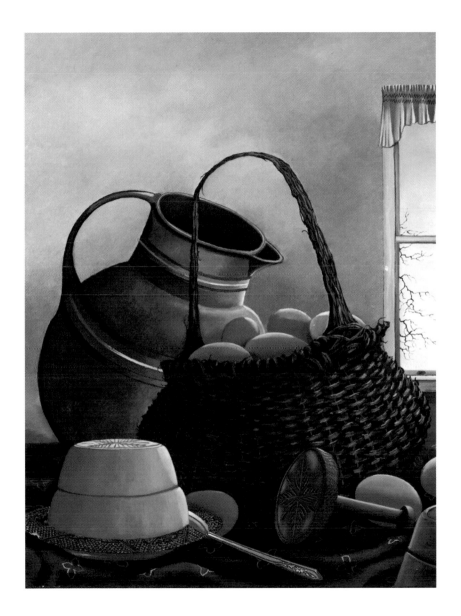

Daily Grind

Oil on linen, 18 x 24 • 1995

ALTHOUGH MOST PEOPLE might think that this painting goes back to earlier days, I think of it instead as a contemporary still life in the home of someone who chooses to do things the old way. There are still people who hand-grind their coffee beans in an old grinder like this, so faded that you can't read the writing on the label. The sugar bowl shown here is made of a light green bake-proof glass called "Jadite."

The warm earth tones in this painting represent a different palette from those I often work with. I wanted the effect of lamp light, glowing down on the objects below. In this painting, I explored the effects of light as it falls on various textures and angles.

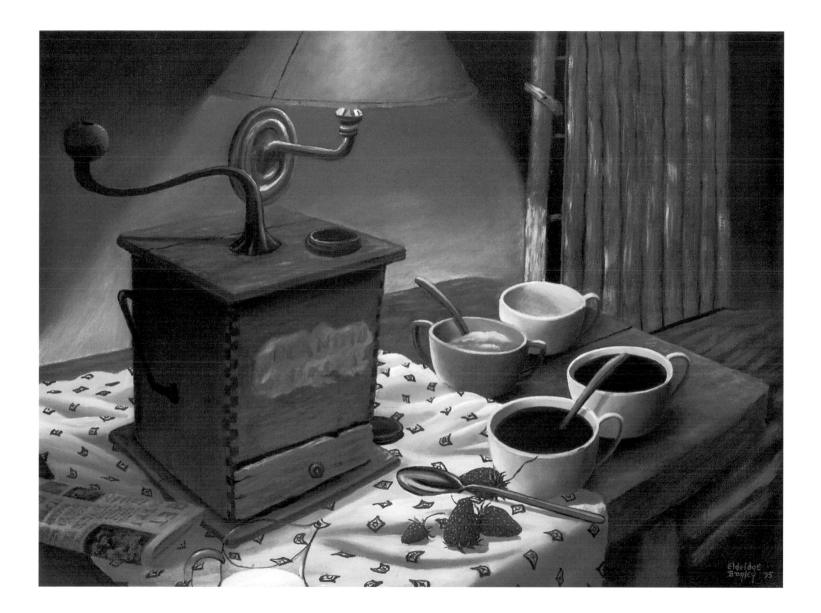

Breakfast Biscuits

Oil on linen, 18 x 24 • 1992

I WANTED TO CAPTURE a warm morning scene here, with fresh-baked biscuits, butter, and jam. I worked with perspective, so you are looking down on the scene. Even the flowers lean down toward the plate. In the corner, you get a glimpse of a chair at the table. The newspaper gives a jolt of reality in the midst of this comfortable meal. I like to think that such details prompt people to ask questions such as, "What's the day's news?" or "Is that a local paper?"

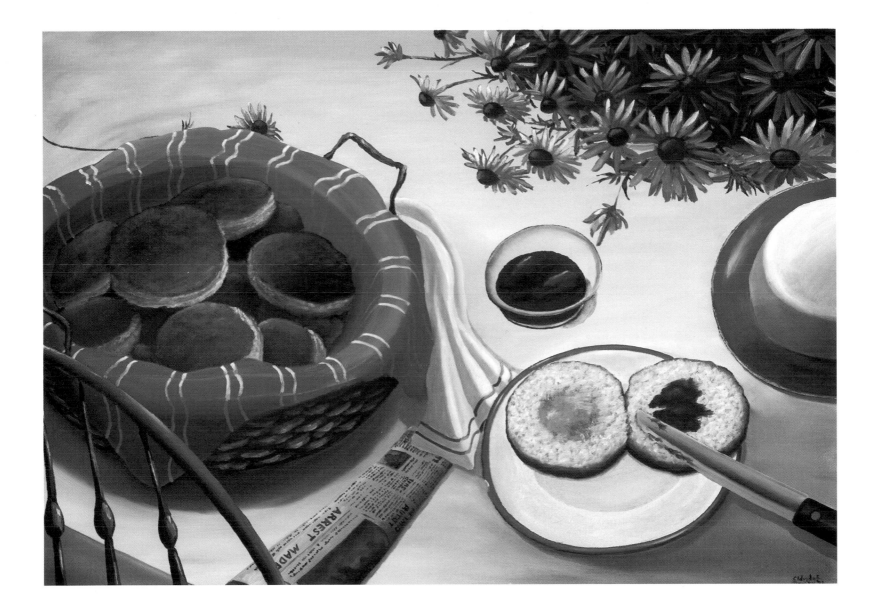

Fruit Pan

Oil on linen, 18 x 24 • 1995

AT FIRST GLANCE, this appears to be a traditional still life. Yet comparing it with other still lifes I have done, it stands out from the rest of them, particularly in my choice of colors. I had never achieved these colors before—the deep red-purples in the plums, the deep aquas of the pan and the pitcher, the rosy reds of the peaches. I consider this painting a minor milestone, especially for the expansion of palette that it represents.

I wanted to give the objects in the painting a weathered, realistic look. There are chips on the enamel of both the pan and the cupboard, and the paint on the drawers is weathered. The spiky house plant leaves and the square tiles of the floor contrast with the curving lines of the pan and its contents.

Although a gauzy curtain hangs over the window, I do give the viewer a glimpse to the outside. My goal is to create a sense of depth, so someone can look not only at the main ingredient of the painting but also beyond it, for a feeling of space and distance.

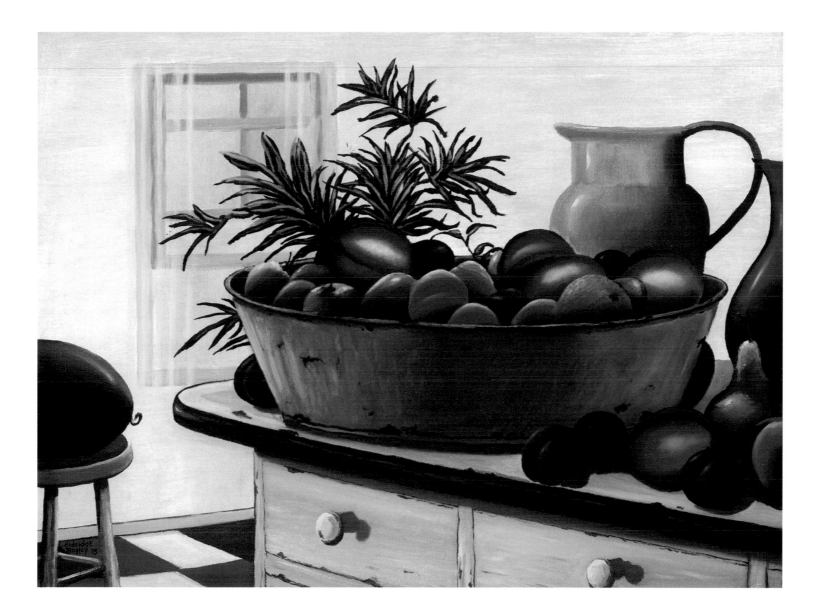

Clair de Lune

Oil on linen, 18 x 24 • 1994

THIS PAINTING WAS INSPIRED by Debussy's *Clair de Lune,* one of my favorite pieces of music. I tried to pull together a collection of images brought to mind for me by that composition.

It's a beautiful spring night. A balmy breeze is gently swaying the trees. The moon is out. The lightning bugs are just starting to sparkle. You can hear the first frogs of the season, croaking down by the creek. I associate *Clair de Lune* with this special time of year. I'm not quite sure why.

In the painting, a piece of music—I think of it as *Clair de Lune*—sits at a beat-up old upright piano, the kind my brother and sister and I played in my parents' house when we were children. All three of us practiced our music lessons on that piano. There's a cup of coffee sitting by the music, as if someone just got up for a moment and will come back soon to play the music once again.

In this painting, I wanted to evoke a feel for both the source of the music—the piano, where someone would sit and play it—and also what I imagine to have been the original inspiration for its composition—a moonlit spring night.

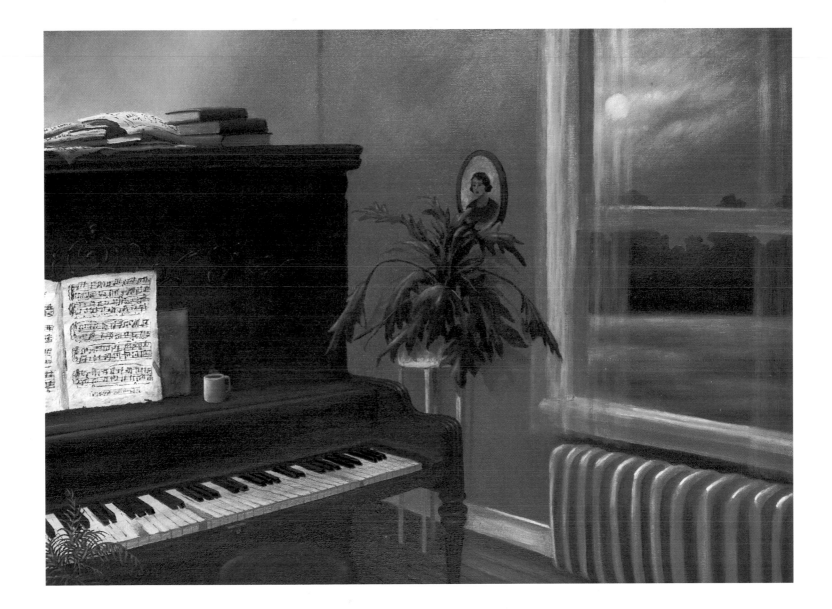

Zinnias

Oil on linen, 18 x 24 • 1994

THE HUES IN THIS BOUQUET of garden zinnias are ones that I do not ordinarily tackle. I expanded my palette to paint them, and to convey the complex textures and surfaces in a bouquet of flowers. Part of the overall composition plan here was to establish a field of understated, subdued tones—the floor, the table, the wall, the glimpse to outside—and then throw the colors of the flowers on top of that.

I think of this scene as taking place inside a little outbuilding. Somebody came in after having cut the bouquet. That person took off the felt hat and placed it on the table with the scissors and the rusty bucket full of flowers.

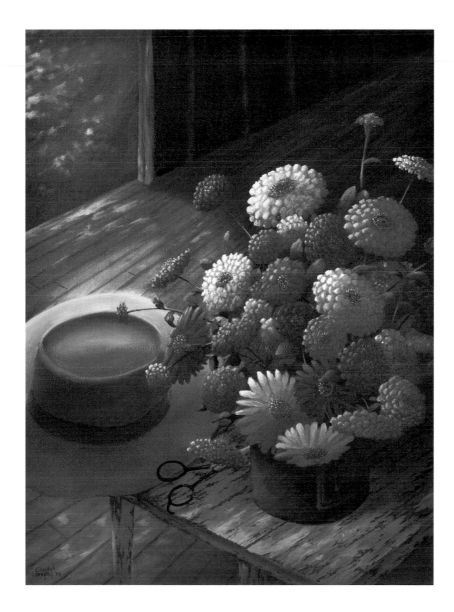

Documentaries

The Lucy Days

Oil on canvas, 18 x 24 • 1989

THIS SCENE COMES straight out of my memory. It's the mid-1950s, and this is my family. My father is drinking a cup of coffee. My mother is shelling peas. My younger brother is still in a playpen. My sister and I are avidly watching *I Love Lucy*. I even remember this episode, when Lucy dressed like Carmen Miranda. Ricky has his hand on his forehead. You can almost hear him saying "Ay-yi-yi," as he so often did.

I included a lot of details here that set this piece in its era. The style of the black-and-white TV, the lamp and doily on the side table, the furniture—all say it's the '50s. The photos on the table could be my grandparents, or my parents in their younger days, or they could even be school portraits of my sister and me.

Our family really did look forward to watching *I Love Lucy* together every week. It was one of those wonderful moments in history when the whole family found something they agreed on for entertainment.

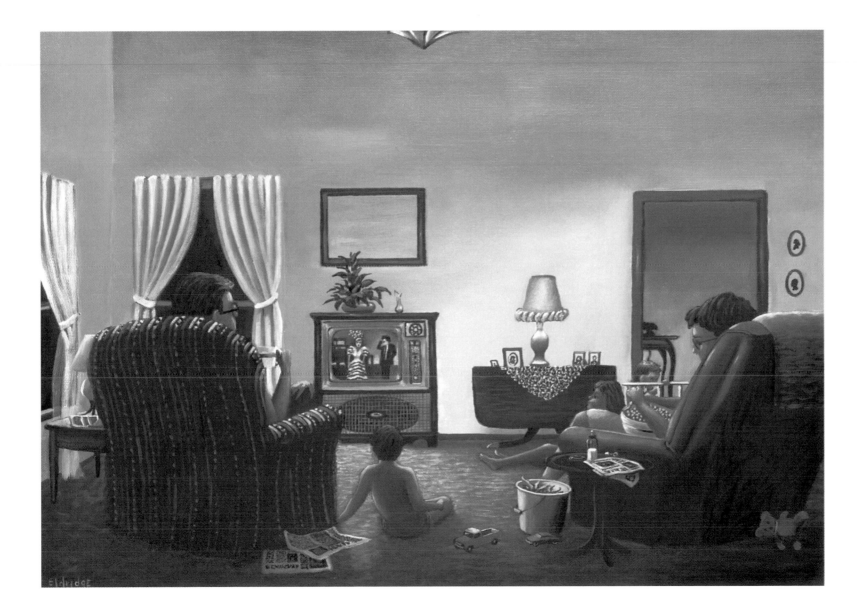

Umbrella March
Oil on masonite, 14 x 21 ³/₄ • 1983

IT'S AN EARLY SPRING DAY. The leaves are just sprouting and the wind is gusting hard. It's almost time for church services to begin. You can't see the people—except the two in the foreground—but you can tell by the line of umbrellas that they are going to church. The woman in front has lost her umbrella, and the boy is trying to help her catch it as it gets tossed high by the wind.

This church is not a particular one that I know, but it is like so many churches that dot the countryside in Southside Virginia, with a few arched windows, a little steeple, and a roofed entryway.

This is an early painting, and I look back upon it as an attempt to capture the elements of a stormy day. I wanted to convey the movement of the wind, the falling rain, and a few puddles in the dirt road. The palette is subdued, brightened only by the color of the umbrellas. I think that the hues of all the umbrellas tell us about the personalities carrying them.

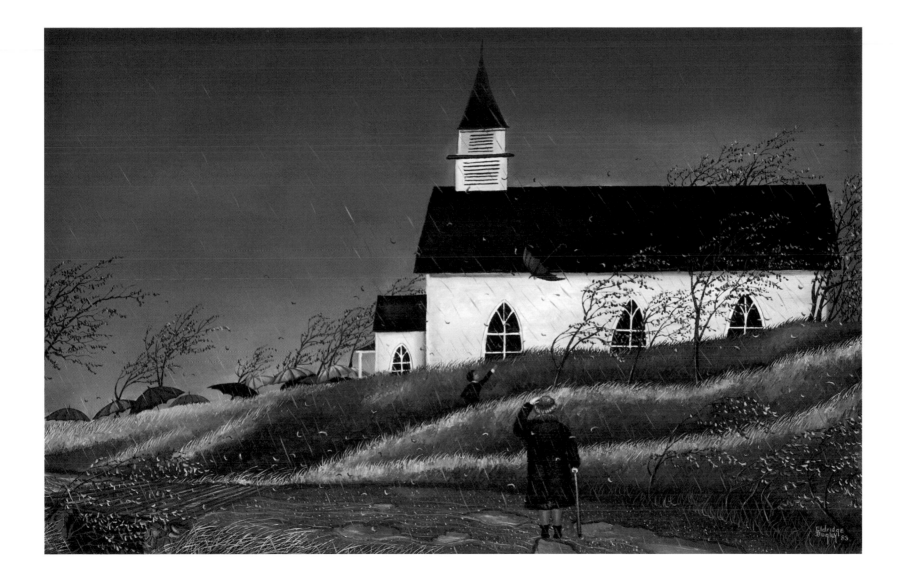

Silver Screen

Oil on masonite, 16 x 20 • 1987

There's a summer place,

Where it may rain or storm,

Yet I'm safe and warm,

For within that summer place,

Your arms reach out to me,

And my heart is free from all care.

by Mack Discant & Max Steiner

© 1959, 1960 Warner Bros. Inc.

Used by permission.

ALTHOUGH THERE IS NO PLACE now close to home to go to a movie, there once were several options. Between Kenbridge and Victoria, there was one drive-in, then there was the Grove Drive-In, just fifteen miles from my home. You mention the Grove to anybody around here in their thirties or older, and they know what you're talking about. A windstorm blew it down some years ago, and that was the end of an era.

The drive-in theater was such a social scene. You could look around, and you would recognize people by the cars they drove. The screen seemed so big, and you would hear the sound coming from each little loudspeaker. I remember seeing John Wayne films as well as the movies *Shenandoah* and *A Summer Place* at the drive-in. But seeing the movie was only half the experience. It was more a matter of just being there with your friends and other families.

I tried to convey that social feeling in this painting, with people walking around and looking other ways, as well as watching the screen. I enjoyed the challenge of creating a black-and-white image on the screen, set against the fading sky, with all the color concentrated in the lower half of the painting.

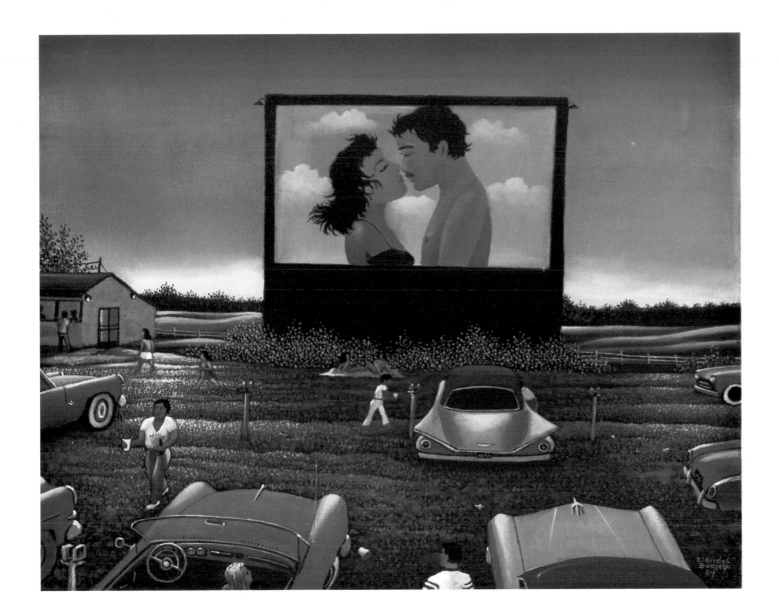

Signs of the Times

Oil on masonite, 16 x 20 • 1979

I REMEMBER the Burma Shave sign posts from the days when I was a kid, but this is the only one of their slogans I remember completely. This painting doesn't really have a deep message. It's a memory that I hold, and one I thought maybe others could recall, of the days when big-finned cars swooped along country roads and Burma Shave signs entertained travelers.

Although the emblem on the trunk of this car looks like a Cadillac, I didn't paint details exactly like a Cadillac from those days. In my current work, I focus more on details true to actual cars of a particular era. I have always loved to draw cars and recall sketching car designs years before I ever thought of myself as an artist. I loved playing with toy cars as a child and still enjoy them as a hobby.

Bus Duty
Oil on linen, 18 x 24 • 1996

I TAKE DELIGHT in old abandoned buildings and vehicles. I like to imagine what they once were like and what purpose they served. There is no shortage of them in rural Virginia. They populate our landscape, and so I paint them as part of the world in which I live.

These two abandoned school buses are standing sentinel around the old one-room schoolhouse. They sit, poised, almost as they must have when children attended school and laughed and played in the schoolhouse yard. But now, weeds have overgrown the yard all around the schoolhouse. The remains of school desks lie like ghosts in the yard.

I practiced a favorite technique to portray the grass and weeds in this landscape, creating the green field with a fluffed-out stroke and then going back and adding each leaf, a brush stroke at a time.

I also painted a number on the bus in the left-hand side of the painting. Number 32—that was the number of the schoolbus that I rode.

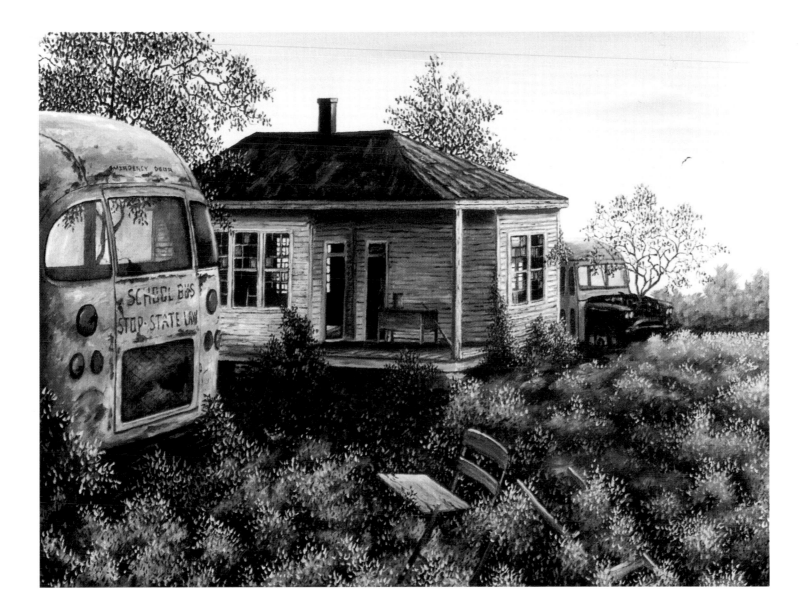

Camp Pickett Summer

Oil on canvas, 24 x 30 • 1992

I LOOK UPON THIS as one of my milestone paintings. It is among the larger pieces I have done, and the subject matter is somewhat of a departure from my focus on rural life.

Camp Pickett was built near Blackstone, Virginia, soon after the bombing of Pearl Harbor, and served as a training base during World War II. Pickett played a big part in the local economy, as military personnel stationed there patronized local businesses. Also, many local men, including my father and uncles, were hired to help with the construction of hundreds of buildings on the post. The name was eventually changed to Fort Pickett. In the late '60s and early '70s, I attended National Guard summer camps there.

The World War II era predated my birth but, combining known facts with ideas from my imagination, I produced this rendering of Camp Pickett as a flashback to that time. In the foreground is a 1939 Willys. While one woman waits inside the car, another shares a letter with a soldier. Within a background of military vehicles and barracks, soldiers wait in line to enter the mess hall.

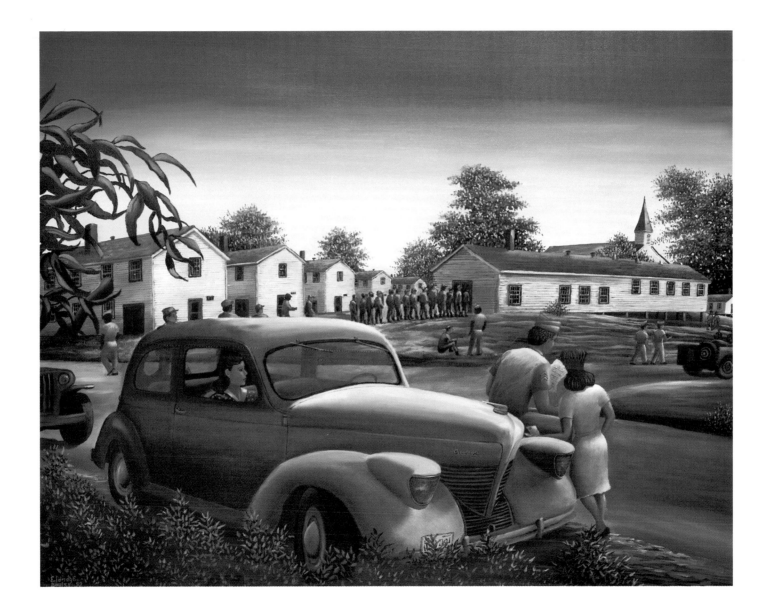

Home Front

Oil on canvas, 24 x 18 • 1987

I NEVER SERVED IN A WAR, so I hold no war scenes in my memory. Most of my experience of war has been through the stories of the people back home.

In my mind, the woman in this painting is on the phone with her husband, the man in the picture, who is serving in the military overseas. The package may be ready to ship off to him. The letters may have been written by him. All those details are open to interpretation. The crocheted doily on the table gives a feeling of home. The irises, and the fact that the woman has kicked off her shoes to enjoy the fresh air coming in the screen door, tell us that this is in late spring.

In this painting, I chose to give the viewer the feeling of looking through the house to the outside.

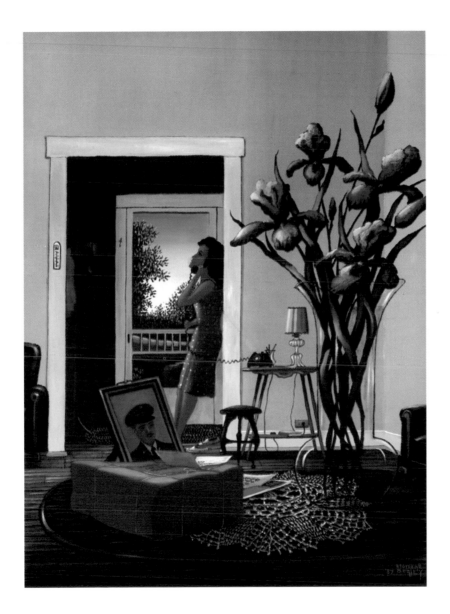

Summer of '69

Oil on linen, 18 x 24 • 1993

IN THE SPRING OF 1993, I visited the Vietnam War Memorial. It moved me deeply. Several weeks later, I painted this: my own little tribute to the people who fought and suffered in Vietnam. It is one of my personal favorites, among all my paintings.

Outside, life goes on as usual. It's a calm landscape, with folds of green grass, a little house, the deep green leaves of trees, even the bountiful red bloom of the roses. But inside, the television image tells the story of great tragedy. Even in your own living room at home, the horrors of war are thrust upon you. You can't escape it.

There is a lot of intent packed into this painting. Above the window sash, I painted the faint outline of the Vietnam War Memorial. Sitting on the television is a faceless portrait of a man. That face could be anyone—the son of the people who live in this house, the man of the house himself, or a friend or relative involved in the conflict pictured on the television screen. I scattered a few toys outside in the yard: a ball and a toy truck. The Army truck conveys the sense that while children are playing war games at home, real war is taking place somewhere else in the world. I decided to leave the house on the hill dark and unlit, as if no one is there, representing emptiness and loss. Still, the roses bloom outside the window, symbols of life and hope.

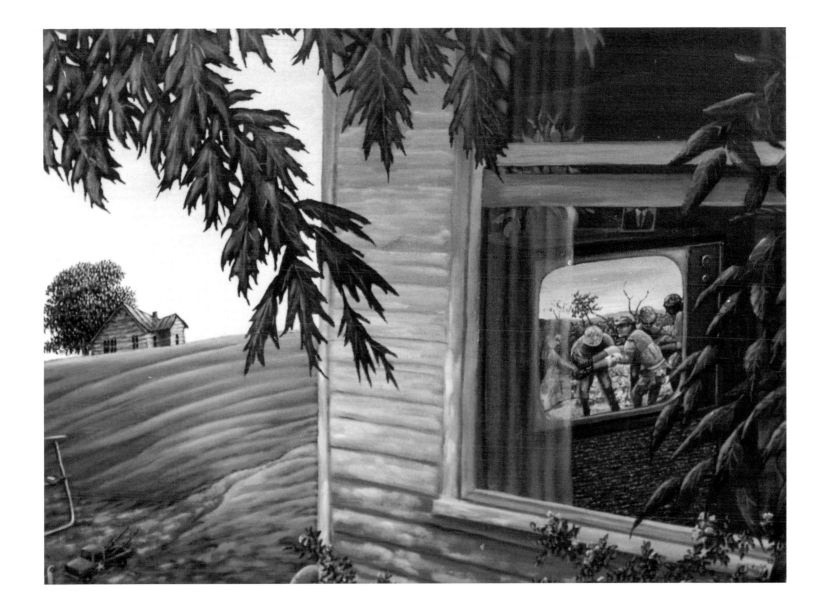

Tin Man

Oil on canvas, 18 x 24 • 1989

THIS PAINTING is a bit of a departure for me. In one way, it has a strong message. But in another, it leaves a lot to the imagination. I don't think I ever reached a conclusion in my own mind about just what is going on here.

The painting includes many elements that are typical of my work: the little country house with a warm light on inside, the green folds of land, the road cutting through, establishing a sense of perspective. But those elements are only background to the major subject in this painting.

Cutting into the picture is the woman, driving a bright yellow car, speeding down the country road, and drinking a can of soda. She probably doesn't even notice the man she has just passed, but he is eyeing her as she drives by.

Litter is a real problem in rural areas. I have my own memories of the days when we would collect soft drink bottles along the side of the road, wash them out, and take them to the store to collect a little money. As I look at this painting, I ask myself a lot of questions. Is the woman conscious of the problem, or is she part of the problem? Is the man hoping she will throw out her empty can, or hoping she won't? And hasn't he left behind pieces of trash, just picking up the aluminum cans he can turn into money? The painting is open to interpretation, leaving questions for the viewer to answer.

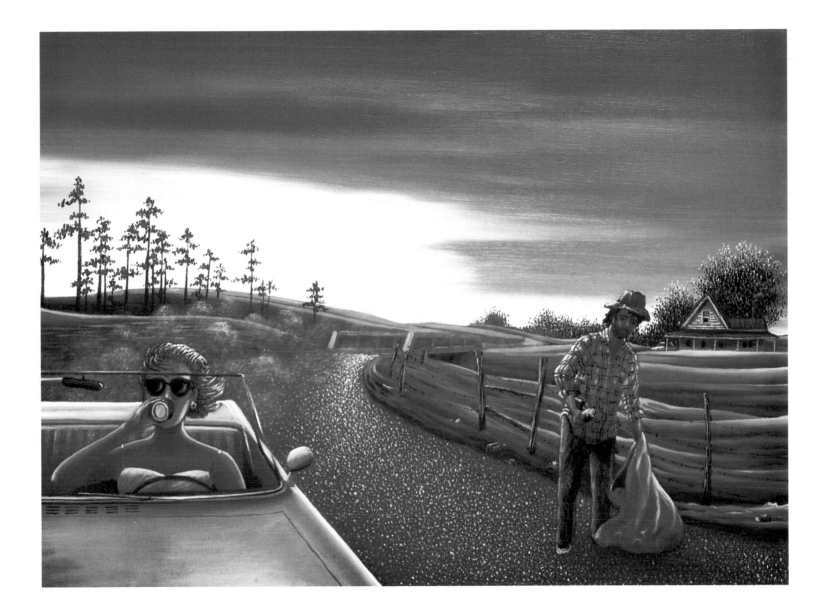

Blue Moon Motel

Oil on linen, 18 x 24 • 1993

A FEW YEARS AGO I drove down to Florida. Instead of taking the fast-track interstate, though, I moseyed on down along Highway 1. This was the way people used to drive south, but now the highway and the places it passed seemed like ghost towns, throwbacks to earlier days. Although I didn't really see a Blue Moon Motel—I made up that name—I certainly did see a lot of buildings like this one. A motel like this must once have been a thriving business, but now it is sinking, rotting, disappearing, retreating back to nature, overtaken by vines and weeds.

To give this scene even more of a sense of history, I placed two rusty old cars in the parking lot. That's a '58 Plymouth and a '56 Oldsmobile. They, too, are dead and abandoned.

One of my plans, as I painted this picture, was to use a subdued blue palette of colors, to show the passage of time, the time of day, and the sense of lifelessness in the scene.

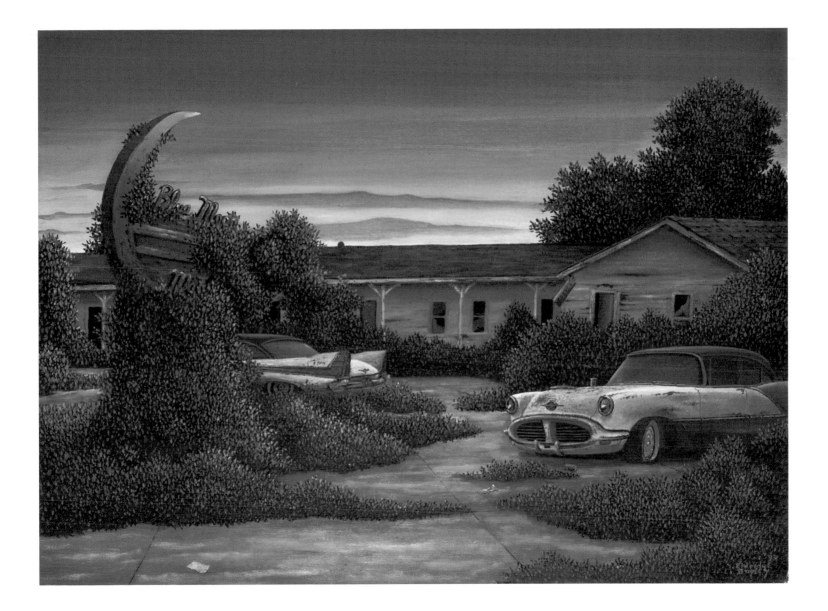

On Grassy Key

Oil on linen, 18 x 24 • 1996

THIS IS ANOTHER of my favorites. I had so much fun with this painting. When my wife and I visited the Florida Keys, I watched for a motel that looked as if it could have come from the 1950s, a building that captured the lavish, colorful, energetic, gaudy spirit of those times. I found what I was looking for on Grassy Key, at the Flamingo Inn.

The lines and the colors—that light aqua and bold pink—are just as we found them. I even painted the signs as I saw them. The only change I made was to drop the price of accommodations a little, to bring the figure back in keeping with earlier times. Then I plunged into this world of colors so different from those that surround me in Southside Virginia. I plunged into the mindset, too. What extravagance!

I added two cars that seemed to belong in this landscape. To the right, you see the corner of an early-model Thunderbird. The car in the center is a Packard Caribbean. They didn't build very many of those, and they used these very colors: white on top, a stripe of bright pink down the middle, and black or charcoal down below.

I find that I do the most growing as an artist when I put myself to a task like this, trying new perspectives, colors, subjects, angles, and tones.

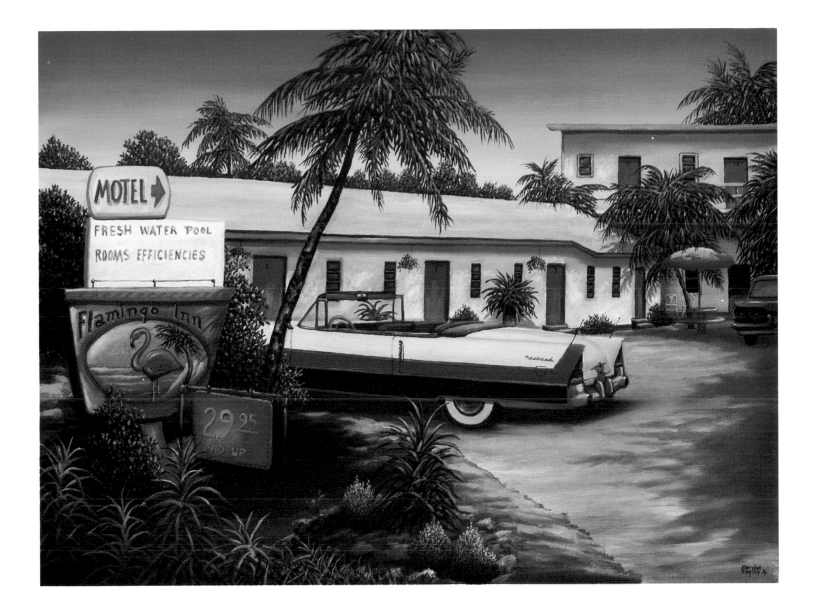

Thank you to the owners of paintings that appear in this book:

Early Garden (cover):	Carpenter Company

Farm and Family

Last of the Fireflies:	Mary Graybeal
Shipping Cream at the Kenbridge Depot:	Stephen & Helen Larson
Checking the Barn Fires:	Eldridge & Beth Bagley
The Loss:	Russell & Barbara Mait
Market Day:	Imperial Processing Corporation
Monday and Rain:	Jim & Doug Watkinson
The Apple House:	Grayson & Nancy Bagley
Game Checking Station:	Julia J. Norrell

Struggles

This Land Is My Land:	Julia J. Norrell
Habitat:	Carolyn Gershfeld & Judy Schub
Rainless Summer:	Pat Schaub
Ann at the Old House Window:	Julia J. Norrell
Mother's Day:	Eldridge & Beth Bagley
Fly Away:	Greg & Cathy Hooe

Winter

Snowplow:	Carpenter Company
5:07 Departure:	Mr. & Mrs. Charles C. Cosby, Jr.
Home for Christmas:	Eldridge & Beth Bagley

Approaching Christmas:	Julia J. Norrell
Night Train:	Julia J. Norrell
Southern Snow:	Francis Garbarini
Flight #703:	Dolores & Stanley Feldman

When Country and City Meet

The Confrontation:	Jim & Miriam Wickham
Two Roads:	John & Suzanne Hessian
Back Yard Cruise:	Greg & Cathy Hooe
The Exodus:	Al & Margarette Smith

Still Life

In the Stable:	Susan & Pat Hudgins
In the Pantry:	Fabio & Susie Gutierrez
Daily Grind:	Dolores & James Robertson
Breakfast Biscuits:	Wayne Heslep
Fruit Pan:	Ralph & Nancy Amos
Clair de Lune:	Eldridge & Beth Bagley
Zinnias:	Jeanne & Gene Bartolich

Documentaries

The Lucy Days:	Greg & Cathy Hooe
Umbrella March:	Nancy Haynes
Silent Screen:	James D. Wadsworth, M.D.
Signs of the Times:	Helen G. Levinson
Bus Duty:	Mr. & Mrs. Robert Waldruff
Camp Pickett Summer:	James D. Wadsworth, M.D.
Home Front:	Russell & Barbara Mait
Summer of '69:	Julia J. Norrell
Tin Man:	James D. Wadsworth, M.D.
Blue Moon Motel:	Julia J. Norrell
On Grassy Key:	Julia J. Norrell